John Pope-Hennessy

FRA ANGELICO

SCALA/RIVERSIDE

Contents

Consultant for this edition:
Lawrence Kanter

Design: Gianfranco Cavaliere

Photographs: Scala (A. Corsini, M. Falsini
and M. Sarri) except page 11 (Kunst-Dias
Blauel, Gauting-bei-München), 28,
51 and 73 (Réunion des musées nationaux, Paris),
79 (National Gallery of Art, Washington).

Printed and bound in Italy by
Sogema Marzari S.p.A. Schio, 1989

Life

The artist whom we know as Fra Angelico and who was known to his contemporaries as Fra Giovanni da Fiesole, was born in the Mugello in the vicinity of Vicchio, probably at San Michele a Ripecanina. According to Vasari, he was born in 1387 and received the Dominican habit in 1407 at the age of nineteen. But it can be shown that he was still a layman on 31 October 1417, when, as 'Guido di Piero dipintore del popolo di santo Michele bisdomini', he was proposed by a fellow artist, the miniaturist Battista di Biagio Sanguigni, for membership of the Compagnia di San Niccolò in the church of the Carmine in Florence. He is thus likely to have been born between 1395 and 1400, roughly ten years later than is indicated by Vasari. In January and February 1418, again as Guido di Piero, he was paid for an altarpiece for the Gherardini chapel in Santo Stefano al Ponte in Florence. The decoration of the chapel, like that of two earlier chapels in Santo Stefano, had been entrusted to Ambrogio di Baldese, and in the absence of other evidence it is tempting to suppose that Angelico was trained in Ambrogio di Baldese's workshop, and was initiated into miniature illumination by Sanguigni. Not till June 1423 does his name occur in the familiar form 'frate Giovanni di San Domenico di Fiesole', in connection with a painted Crucifix for the hospital of Santa Maria Nuova. During the first year of his novitiate he would have been prohibited from painting, and he must therefore have joined the community of San Domenico between 1418 and 1421.

On 22 October 1429 'frate Johannes petri de Muscello' was present at the capitular reunion of the brethren of San Domenico; he attended other capitular reunions in January 1431 and December 1432, in January 1433, when he was Vicario of the convent in the absence of the Prior, and in January 1435. Throughout this time Angelico's clerical status was no impediment to his fulfilling the obligations of a secular artist, and on 14 January 1434 we find him acting as assessor jointly with the Late Gothic painter Rossello di Jacopo for a painting produced by Bicci di Lorenzo and Stefano d'Antonio for San Niccolò Maggiore.

In 1435 a body of friars from the community at San Domenico took possession of the Florentine church of San Giorgio sulla Costa, and a year later, in January 1436, they were confirmed in the possession of the premises of San Marco, where, in 1438, the building of a new convent by Michelozzo was begun. Angelico was not among the friars who moved to San Giorgio sulla Costa in 1435 or to San Marco in the following year, but remained on as Vicario at Fiesole. The first evidence of his presence at San

Marco dates from 22 August 1441. He attended a capitular meeting of the two communities in August of the following year, and in July 1445 signed the act separating the community at San Marco from that at San Domenico in the form: 'Ego frater Joannes de florencia assencio omnibus supradictis in cujus testimonium me manu propria subscripsi'. The probable inference is that Angelico retained his workshop at San Domenico till after 1440, when the painting of the high altarpiece for San Marco was well advanced and the frescoed decoration of the convent was begun, and thereafter transferred it to San Marco. In 1443 he was 'sindicho' of the convent, a post which seems to have involved some measure of financial control.

At an uncertain date, probably in the second half of 1445, Angelico was summoned to Rome by Pope Eugenius IV, who had lived in Florence for some years and was familiar with his work. During the summer of that year the archbishopric of Florence became vacant, and in August a number of names were recommended by the Signoria to the Pope. One of them was a member of the Medici family, Donato de' Medici, Bishop of Pistoia, another was a subdeacon and canon of the Cathedral in Florence, Giovanni di Neroni di Nisio, a third was the Bishop of Fiesole, Benozzo Federighi, a fourth was the Bishop of Volterra, Roberto Cavalcanti, and a fifth was the secretary of the Signoria, Canonico Andrea. For one reason or another the Pope disallowed these candidates, and six months later, on 9 January 1446, he appointed Fra Antonino Pierozzi, then Vicar of San Marco, as Archbishop. There is a persistent tradition first that before this decision was made, the archbishopric was offered to Angelico, and second that Angelico was instrumental in securing the appointment of Fra Antonino. When the process for the canonisation of Fra Antonino was under way in the first quarter of the sixteenth century, no less than six witnesses affirmed that this was so. There is no way of telling whether these statements should be given credence, but the fact that little more than half a century after his death the view entertained of Fra Angelico was of a man capable of administering an archdiocese and of tendering advice on the appointment to the Pope must be reflected in the judgements that we form of his intellectual capacity.

Angelico remained in Rome through 1446 and 1447 (when he was also active during the summer months in the Cathedral at Orvieto), returning to Florence at the end of 1449 or the beginning of 1450. By 10 June 1450 he was Prior of San Domenico at Fiesole. He retained the post for

the normal two-year period, and was still living at Fiesole in March 1452, when, according to the account books of the Duomo at Prato, the Provveditore of Prato Cathedral came to Florence bearing a letter to Sant'Antonino requesting that 'frate Giovanni da Fiesole maestro di dipingere' should undertake the painting of the choir of the Cathedral. Eight days later the Provveditore again visited Florence, this time to interview the painter who agreed to return with him to Prato to discuss the proposal with four deputies of the Cathedral and the Podestà. On the following day horses were hired to take 'el Frate che dipigne' to Prato and back to Fiesole. For reasons we can no longer reconstruct these conversations were inconclusive. On 1 April Angelico returned to Fiesole, and on 5 April the Provveditore was once more in Florence, seeking a painter and master of stained glass to decorate the choir. This time his quest was successful, and the contract for the frescoes was awarded to Fra Filippo Lippi.

After the Prato negotiations Fra Angelico disappears from view. He is mentioned on 2 December 1454, when it was prescribed that frescoes carried out in the Palazzo dei Priori at Perugia should be assessed either by him, or by Fra Filippo Lippi, or by Domenico Veneziano, that is by one of the three living Florentine painters who were most widely admired. In 1453 or 1454 he is thought to have gone back to Rome, but if he did so there is no indication of the work on which he was employed. He died in Rome in February 1455, a few weeks before his patron Pope Nicholas V.

The epitaphs for his tomb in the Dominican church of Santa Maria sopra Minerva were reputedly written by the humanist Lorenzo Valla. That on the wall, now lost, read:

'The glory, the mirror, the ornament of painters, Giovanni the Florentine is contained within this place. A religious, he was a brother of the holy order of St. Dominic, and was himself a true servant of God. His disciples bewail the loss of so great a master, for who will find another brush like his? His fatherland and his order lament the death of a consummate painter, who had no equal in his art'.

On the marble tomb-slab the body of the painter is shown in his habit in a Renaissance niche; beneath his feet is a second inscription:

'Here lies the venerable painter Fra Giovanni of the Order of Preachers. Let me not be praised because I seemed another Apelles, but because I gave all my riches, O Christ, to Thine. For some works survive on earth and others in heaven. The city of Florence, flower of Etruria, gave me, Giovanni, birth'.

Soon after his death, Angelico figures in the De Vita et Obitu B. Mariae of the Dominican, Domenico da Corella, as 'Angelicus pictor ... Iohannes nomine, non Jotto, non Cimabove minor', and later in the century he is mentioned in a celebrated rhymed poem by Giovanni Santi between Gentile da Fabriano and Pisanello, and alongside Fra Filippo Lippi, Pesellino and Domenico Veneziano, as 'Giovan da Fiesole frate al bene ardente'. With the advent of Savonarola, for whom art was a means of spiritual propaganda, there developed a new attitude towards painting; and after Savonarola's death, his followers adopted Angelico, the friar artist, as the pivot around which their theories could revolve. Already in the first narrative account of the artist's life, a brief biography included in a volume of Dominican eulogies published by Leandro Alberti in 1517, is implicit the case that was formulated in the nineteenth century: that Angelico's superior stature as an artist was due to his superior stature as a man. Alberti's eulogy was one of the sources drawn on by Vasari when in 1550 he printed the first formal life of Fra Angelico. Another source was a Dominican friar, Fra Eustachio, who had received the habit from Savonarola, and who, as a man of almost eighty, transmitted to Vasari the conventual legends woven round the artists of San Marco. A fellow Dominican, Timoteo Bottonio, tells us how Vasari 'used often to come to gossip with this old man, from whom he obtained many beautiful details about these old illustrious artists'. From these and other sources Vasari built up his life. 'Fra Giovanni,' he writes, 'was a simple man and most holy in his habits.... He was most gentle and temperate, living chastely, removed from the cares of the world. He would often say that whoever practised art needed a quiet life and freedom from care, and that he who occupied himself with the things of Christ ought always to be with Christ.... I cannot bestow too much praise on this holy father, who was so humble and modest in all his works and conversation, so fluent and devout in his painting, the saints by his hand being more like those blessed beings than those of any other. Some say that Fra Giovanni never took up his brush without first making a prayer. He never made a Crucifix when the tears did not course down his cheeks, while the goodness of his sincere and great soul in religion may be seen from the attitudes of his figures'. In the mouths of nineteenth-century commentators Vasari's words take on a romantic overtone, and this reliance upon inspiration, these empathetic tears, these acts of faith have been recounted by many writers since. Such stories still fulfil the purpose for which they were designed, that of commending the artist's work to simple-minded people in search of spiritual nourishment. They have no contemporary sanction, but they should not be disregarded on that account. What cannot be denied is that the golden thread of faith does run through Angelico's work. There is no painter whose images are more exactly calculated to encourage meditation and to foster those moral values which lie at the centre of the spiritual life.

Early Works
1418-32

The earliest datable painting by Fra Angelico is a triptych in the Museo di San Marco, which was installed on the high altar of the convent church of San Pietro Martire in Florence before March 1429 and was probably completed in the preceding year. In the central panel the Virgin is seated on a gold-brocaded stool in front of a gold curtain, with the Child standing on her lap. Her body is not set frontally, but is slightly turned, with the right knee thrust forwards in the centre of the panel. Her heavily draped cloak is illuminated from the left, and the light falls on the orb held in the Child's left hand and on his raised right arm. No concession is made to decoration save in the gold-brocaded curtain behind the group, in the lion's feet beneath the stool, and in the edging of the Virgin's cloak, which is caught up at the bottom in a number of small folds.

Though a triptych, this is a reluctant triptych in that the step beneath the Virgin's seat intrudes into the panels at the sides and the marble pavement at the sides extends into the central panel. That this was a purposive and not a casual device is proved by the four lateral saints. As in a conventional triptych their heads lie on a common horizontal, but the two outer saints stand slightly forward of those adjacent to the throne, and two of them, Saint John the Baptist on the left and Saint Thomas Aquinas on the extreme right, reveal, even more markedly than the central group, a concern with volume and plasticity. Both in the Virgin and the Baptist a debt to Masaccio is apparent, but the Masaccio whom they recall is the artist of the *Virgin and Child with Saint Anne*, not of the Pisa polyptych or the Brancacci Chapel.

An unusual feature of the altarpiece is that the area between the finials is filled with narrative scenes. They represent on the left Saint Peter Martyr preaching and

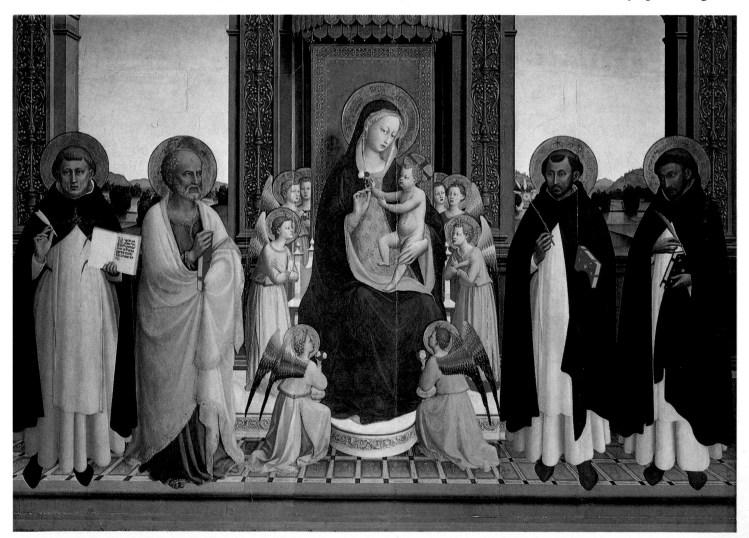

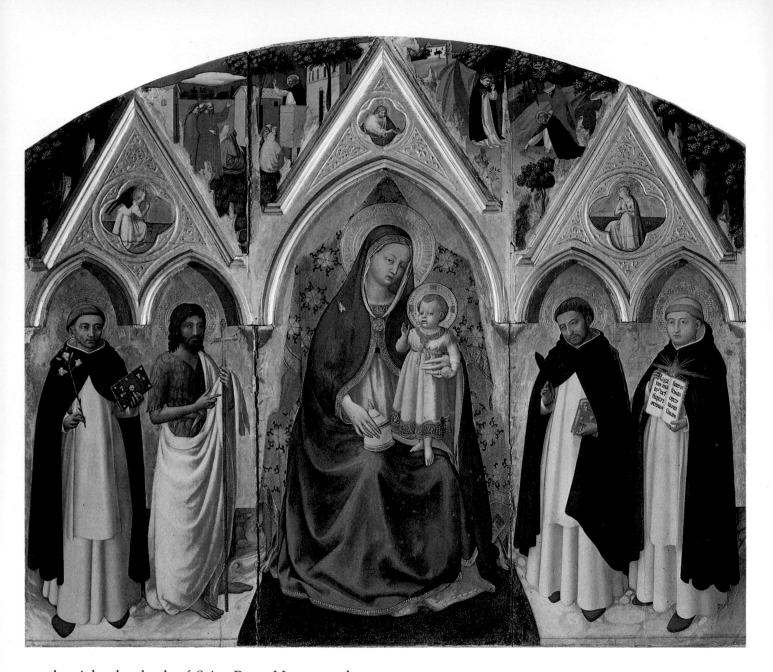

on the right the death of Saint Peter Martyr, and are unified at the back by a curved line of trees which is continued in two panels at the sides. Their date and attribution have been questioned on more than one occasion — they have been regarded as accretions to the triptych by an imitator of Angelico, perhaps Benozzo Gozzoli — but they must from the outset have formed an integral part of the painting, and their style is wholly consistent with that of the figures beneath. The firm drawing of the pulpit and of the adjacent buildings in the *Preaching of Saint Peter Martyr* and the triangular formulation of the figures of the assassin and the slain Saint anticipate the style of Angelico's predella panels in the early fourteen-thirties. The views of the deserted forest at the sides offer an intimation of the part that nature was to play throughout his work.

A missal at San Marco (No. 558) made for Fiesole about 1428-30, shows that Angelico was also active as a miniaturist, but that he was largely unresponsive to the decorative demands of book illustration, carrying the style of his panel paintings over to the manuscript page.

Saint Peter Martyr triptych
1428-9
137x168 cm
Museo di San Marco, Florence.

(right)
Annunciation
c. 33v., Missal no. 558.
c 1430
Museo di San Marco, Florence.

(previous page)
Virgin and Child Enthroned with Saints Thomas Aquinas, Barnabas, Dominic and Peter Martyr (detail).
c 1424-5
San Domenico, Fiesole.
The Altarpiece was rebuilt and the landscape and architectural details added by Lorenzo di Credi around 1501.

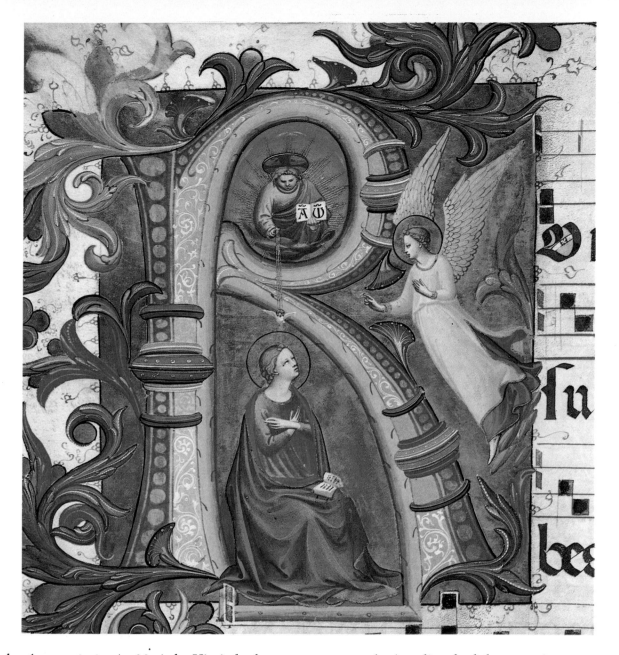

Thus in the *Annunciation* (c. 33v.) the Virgin looks up at the Angel, who floats down towards her from the right, as though she were oblivious of the illuminated letter that impedes her view, while from the top of the initial a foreshortened God the Father drops the Holy Ghost on a gold cord plumb over her head. In a splendid page with the *Glorification of St. Dominic* five circles protrude from the initial I, four of them filled with solidly modelled saints, and the fifth with the scene of the *Meeting of St. Francis and St. Dominic*, treated with the weight of a small panel painting. At the top in a mandorla is the figure of St. Dominic accompanied by four flying angels, whose heads and bodies are lit with the same consistency as the figures in the triptych from San Pietro Martire. The most monumental of the miniatures is *The Virgin as Protectress of the Dominican Order* (c. 156v.), where the upper part of the initial S is filled by a frontal figure of the Virgin with arms outstretched, while below five kneeling Dominicans are grouped round the pink column of her robe.

In 1428, when the Saint Peter Martyr triptych was executed, Angelico had been active as a painter for upwards of eleven years. The sequence of his works during that time is, and in the absence of further documents is likely to remain, a matter of hypothesis. The most important of them is an altarpiece for San Domenico. In 1418, when the Observant community returned to Fiesole after nine years of exile at Foligno and Cortona, the church and convent of San Domenico were re-endowed under the will of a rich merchant, Bernabò degli Agli, whose patron saint, St. Barnabas, was associated with the dedication of the church. A condition of this gift was that the convent should be rendered habitable within two years. On historical grounds, therefore, the altarpiece painted by Angelico for the high altar could have been painted at any time between 1418 and the dedication of the church in October 1435, but in practice it must date from the middle of the fourteen-twenties, three or four years before the painting of the triptych for San Pietro Martire. Some seventy-five years after it was finished, it was transformed by Lorenzo di Credi into a Renaissance

altarpiece in which the Virgin is shown beneath a baldacchino and the saints stand in an architectural setting before a landscape. In its original form it consisted, like the Saint Peter Martyr triptych, of three Gothic panels, that in the centre containing the Virgin and Child Enthroned with angels, and those at the sides with Saints Thomas Aquinas and Barnabas on the left and Saints Dominic and Peter Martyr on the right. It was completed with a predella, now in the National Gallery, London, showing the Risen Christ adored by saints, prophets, angels and members of the Dominican Order, and with ten pilaster panels, four of which, two in the Musée Condé at Chantilly and two in a private collection survive.

A decisive argument in favour of the view that the altarpiece precedes and does not, as is frequently assumed, follow the Saint Peter Martyr triptych is afforded by the space representation. The figures stand on a tiled pavement, which is solidly constructed in the shallow area before the throne but splays outwards in the lateral panels. This feature recurs, to cite two examples only, in an anonymous Florentine triptych of 1419, of which the central panel is at Cleveland, and in an altarpiece by the same artist with Saint Julian Enthroned at San Gimignano. The lateral saints are set on a single plane, the Saint Barnabas and Saint Peter Martyr turned slightly towards the Virgin and the Saint Dominic and Saint Thomas Aquinas posed frontally. The Virgin's head is thinner and more elegant than in the painting from San Pietro Martire, and the linear movement of her cloak is more pronounced, while the naked Child is shown reaching towards two flowers held in her raised right hand.

In Florence in the field of painting, the first half of the fourteen-twenties was a period of intense activity which is no longer fully reconstructible. In 1422 a painter from the Marches, Arcangelo di Cola, produced an important altarpiece for the Bardi chapel in Santa Lucia dei Magnoli. A year later another Marchigian artist, Gentile da Fabriano, completed the *Adoration of the Magi* for Santa Trinita, and thereafter started work on the Quaratesi polyptych for San Niccolò. In 1423 a polyptych for an unknown destination was painted by Masolino, of which only the central panel, at Bremen, survives, and this was followed, perhaps in 1424, by a triptych by the same artist for the Carnesecchi altar in Santa Maria Maggiore, of which the central panel is known from photographs and one of the lateral panels, with Saint Julian, is preserved. This phase reaches its climax in about 1425 in the more tactile style of Masolino's elaborate *Madonna* at Munich and in a work painted by Masaccio and Masolino for the church of Sant'Ambrogio, the *Virgin and Child with Saint Anne*. The central panel of Angelico's altarpiece for San Domenico shows some affinity to Masolino's Santa Maria Maggiore triptych, but the contrast in the decorative content of the two paintings is very marked. The cloak of Masolino's Virgin sweeps forward in impulsive, self-indulgent folds,

Assumption
c. 73v., Missal no. 558.
c 1430
Museo di San Marco, Florence.

(right)
Glorification of St. Dominic
c. 67v., Missal no.558.
c 1430
Museo di San Marco, Florence.
Five circles protrude from the initial I, four of them filled with solidly modelled saints, and the fifth with the scene of the Meeting of St. Francis and St. Dominic.

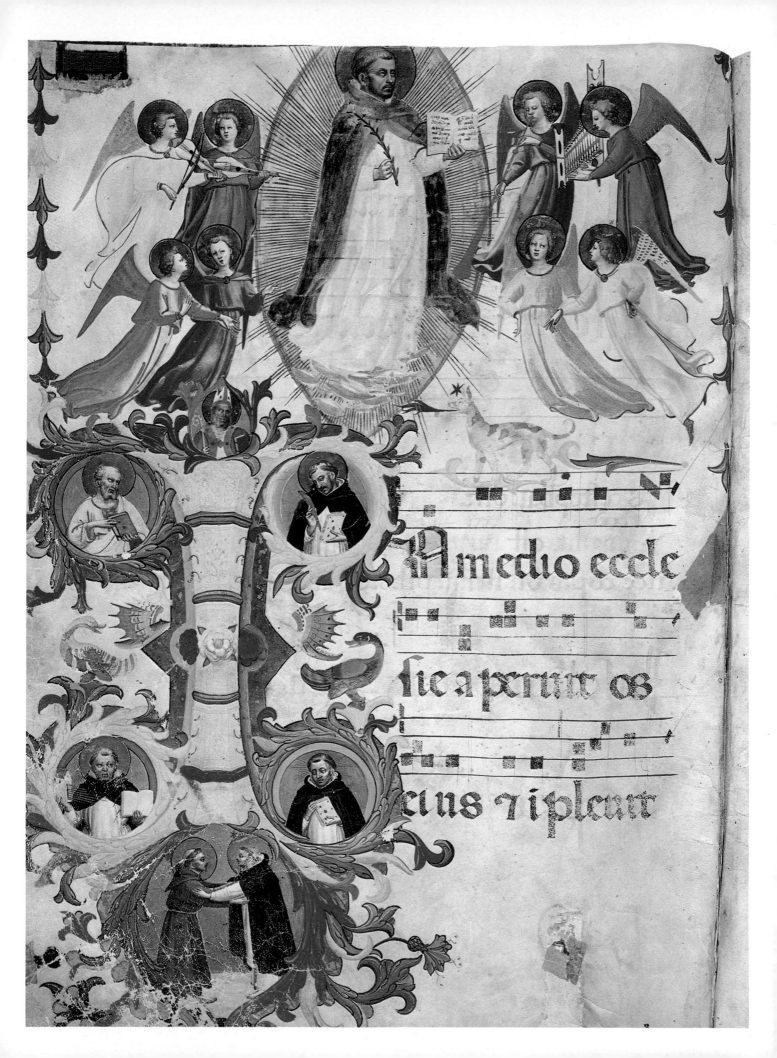

In medio eccle

sie aperuit os

eius replevit

whereas that of Angelico's Madonna is handled with self-imposed restraint. More important for the structure of the painting is the influence of an artist whose pre-eminence was recognised by every progressive painter in the half-decade before the emergence of Masaccio, that of the sculptor Ghiberti. In Angelico's painting the carefully rendered throne is surrounded by eight angels, two kneeling in the foreground and the remaining six forming a niche behind the central group. This use of the principle of circularity is not a unique phenomenon but in every case it seems to go back to Ghiberti, and specifically to the stained glass window of the *Assumption of the Virgin* made from Ghiberti's cartoon in 1404-5 for the façade of the Cathedral, where the angels surrounding the massive figure of the Virgin establish the space in which the scene takes place.

The influence of Ghiberti was of continuing importance for Angelico, and so was that of an artist whose shadow also falls across the altarpiece, Gentile da Fabriano. From the time of his arrival in 1422 till his departure three or four years later, Gentile was the dominant painter in Florence, and the decorative splendour and restrained naturalism of his style could not but leave their mark on younger artists. Angelico's prime debt was to the Quaratesi polyptych, as can be seen clearly enough from the type of Angelico's Child in the San Domenico altarpiece, with distended cheeks and curly hair, and of the angels beside the throne. To exponents of the Dominican Observant aesthetic, the highly ornate style of Gentile's *Adoration of the Magi* would have been unacceptable, but the description of natural phenomena in its predella and in the predella of the Quaratesi altarpiece struck a responsive chord in Fra Angelico, and a decade later inspired the vivid lighting of the storm in the Linaiuoli *Martyrdom of Saint Mark*.

Angelico's development in the years which separate the Fiesole high altar from the Saint Peter Martyr triptych was rapid and is marked by the increasing influence of Masaccio over that of Gentile. His evolving concern with space and the increasing lucidity with which his images are formulated are illustrated in a *Virgin and Child* of unknown provenance in the Museo di San Marco. The central panel of a disassembled polyptych, it is based on the central panel of an altarpiece painted by Lorenzo Monaco for Monte Oliveto in 1406-10. The relationship is one of iconography rather than of style, and if the cartoons of the two paintings are compared, it will be found that in Angelico's the linear features of the Virgin's cloak are much reduced and the Child's pose is more erect. New features introduced into the scheme are a carefully rendered marble seat and step. The latter extends to the front plane, and looks forward to the more elaborate step in the central panel of the Linaiuoli tabernacle of 1433. Further proof of Angelico's new-found command of space is afforded by a small *Madonna and Child with twelve Angels* at Frankfurt, which uses some of the same motifs as the central panel of the Fiesole altarpiece, but is enriched by the intro-

duction of a beautifully rendered perspective throne raised on three steps with a hexagonal tabernacle over it. Though the architectural forms are less classical than those used by Ghiberti in the later panels of the first bronze door, the means by which they are portrayed, and the relation to them of the carefully spaced ring of angels, are deeply Ghibertesque.

Virgin and Child Enthroned
c 1430
189x81 cm
Museo di San Marco, Florence.

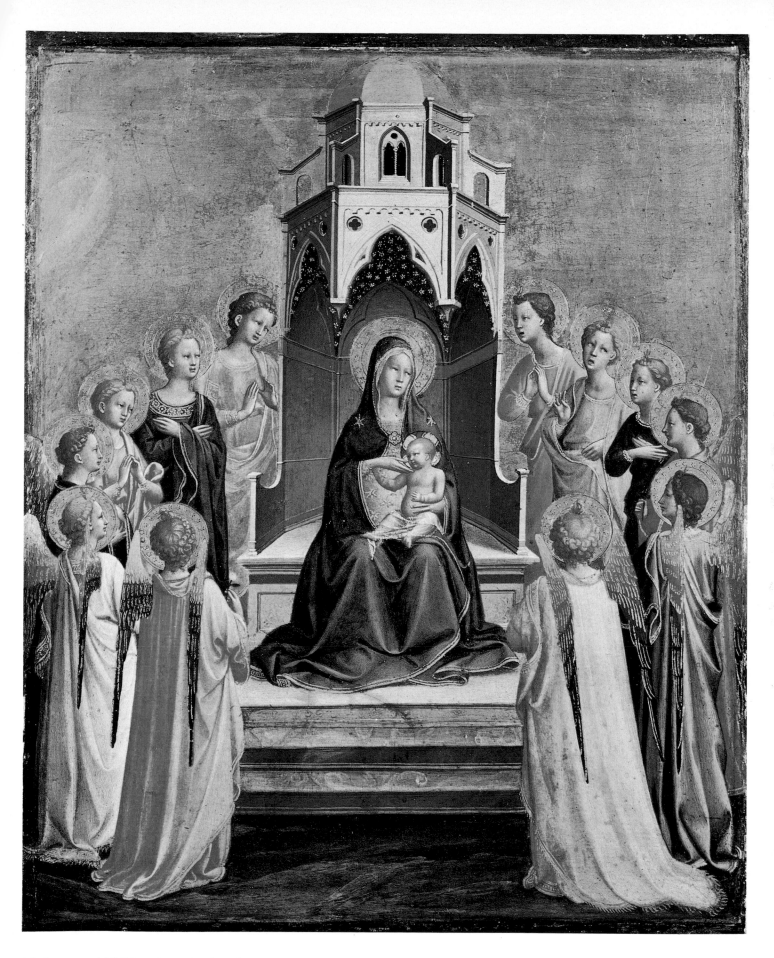

Madonna and Child with twelve Angels
c 1430
37x28 cm
Staedelsches Kunstinstitut, Frankfurt-am-Main.

The device of the receding rectangle used in the foreground of this *Madonna* is employed in a rather different form in the *Last Judgment* in the Museo di San Marco, which must have been painted about 1430 and may have been commissioned for the Oratorio degli Scolari in Santa Maria degli Angeli in the summer of 1431. The panel formed the upper part of a seat used by the priest during High Mass, and its shape for that reason is unorthodox. The upper lobe, containing the figure of Christ as judge, is extended at the base to form an oval mandorla framed by angels and flanked by the Virgin and St. John, with saints and apostles at the sides set on two shallow diagonals. Paradise and Hell are depicted in two rectangular extensions at the sides, and in the centre is the Resurrection of the Dead, unified by a perspective of open graves which carries the eye through the whole depth of the picture space to the pale blue horizon at the back. The only parallel for this device occurs on the Arca di San Zenobio of Ghiberti, and the system whereby it is projected is also found in Ghiberti, in the *Story of Isaac* on the Gate of Paradise. Angelico cannot have drawn directly on either of these models —

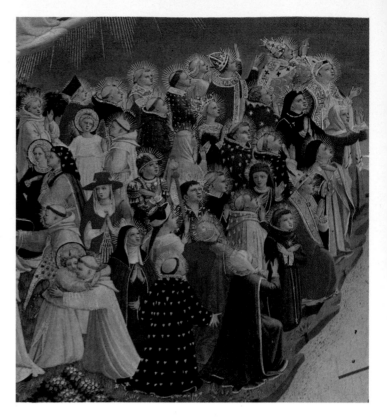

Last Judgment
c 1431
105x210 cm
Museo di San Marco, Florence.

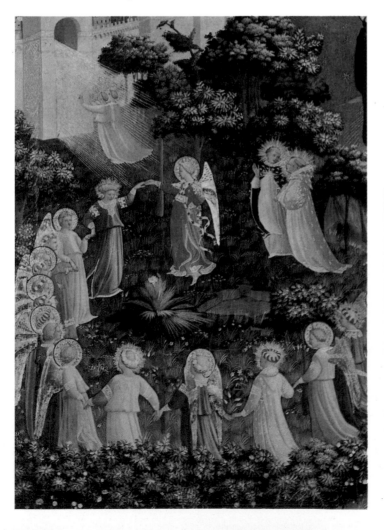

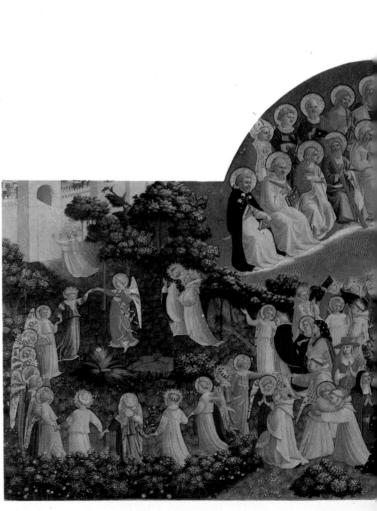

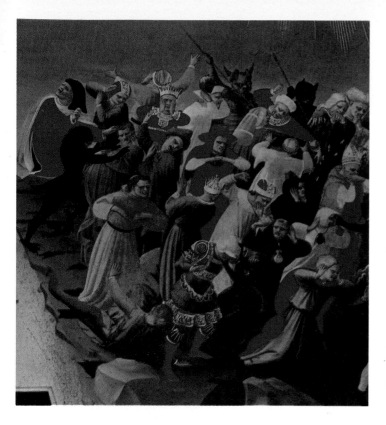

the relief of the *Miracle of St. Zenobius* dates from 1437, and the *Story of Isaac* was evolved at some time between 1429 and 1436 — but the analogies leave little doubt that Ghiberti must have been Angelico's mentor at this time. This applies also to the figures of the condemned, which recall those in the only scenes of violent action by Ghiberti that we know, the *Expulsion of the Money-Changers from the Temple* on the first bronze door and the *Arrest of the Baptist* on the Siena font. Impressive as is its design, it is debatable how far the panel was executed by Angelico. The Christ and the saints and apostles at the top must be in great part autograph, but the angels on the left are much inferior to those in the *Madonna* at Frankfurt and may be due to the assistant of Missal No. 558. The *Last Judgment* was not a major commission, and the decision to entrust part of its execution to members of the studio suggests that at the time Angelico must have been personally involved in the execution of some more important work. This was not the Linaiuoli triptych, which was commissioned in 1433, but the work that immediately precedes it, an altarpiece of the *Annunciation*.

(overleaf)
The Damned, detail from the Last Judgment.

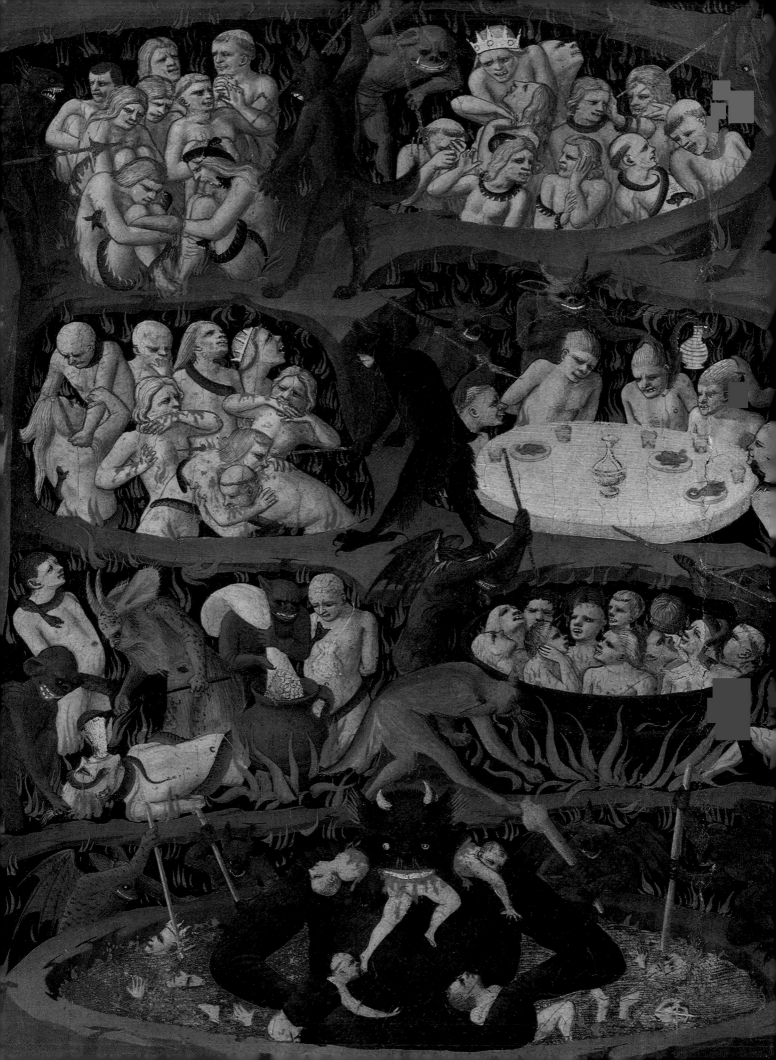

Panel Paintings and Frescoes
1432-8

In 1432 Angelico is known to have been at work on a painting of the *Annunciation* for the church of Sant'Alessandro at Brescia. Nothing further is known about the picture. It has been stated that it was delivered to Brescia and was destroyed, but there is no proof of its delivery nor indeed of its presence in the church. Moreover, eleven years later another painting of the *Annunciation* was commissioned for Sant'Alessandro, an altarpiece by Jacopo Bellini for which payments were made in 1443, and which is still preserved at Brescia. There is, however, one altarpiece of the *Annunciation* by Angelico, formerly in the Gesù at Cortona, now in the Museo Diocesano, which dates from these same years — it has been argued with great cogency that it was already in existence in 1433-4 — and it is possible that this is the painting planned for Brescia, which, for lack of funds or for some other reason, was diverted to a new recipient.

The *Annunciation* at Cortona is Angelico's first indubitable masterpiece and one of the greatest achievements of Florentine painting. The scene is set beneath a loggia closed on two sides by Brunelleschan columns and at the back by an arcaded wall. On the right the Virgin, her hands crossed on her breast, leans forward from her gold-brocaded seat, reciting the words of St. Luke inscribed in gold letters on the surface of the panel: 'Behold the handmaid of the Lord; be it unto me according to thy word'. Confronting her with a half-genuflection is the Angel, his forefinger raised in expostulation as his lips recite the sentence: 'The Holy Ghost shall come upon thee, and the power of the Highest shall overshadow thee'. A golden dove hovers over the Virgin's head. To the left is an enclosed garden with a symbolic palm-tree, and beyond it, at a point to which the eye of the spectator is directed by the pink cornice of the building, is the scene of the Expulsion from Paradise. The painting of the flesh of the two figures is richer than in any previous painting — particularly striking is the Masolino-like facture of the Virgin's hands — and the Angel's wings, so disposed that the forward tip falls in the exact centre of the panel, have a sweep and grandeur that are indeed miraculous.

Just as the altarpiece of the *Annunciation* painted by Simone Martini in 1333 dictated the treatment of this scene in Siena for more than half a century, so the Cortona altarpiece, with its pervasive sense of mystery, its gentle, symbolic lighting and its infectious earnestness, formed the source of countless adaptations and variants.

The predella of the Cortona *Annunciation* is in large part autograph, and contains five scenes from the life of the Virgin and two scenes from the legend of St. Dominic. Two of the most magical are the scenes of the *Visitation* and the *Presentation in the Temple*. In the former the Virgin and St. Elizabeth are isolated against a shady wall; on the left is a distant view over Lake Trasimene, and in front of it is a woman climbing up the hill, painted with such gravity that it has been ascribed, wrongly, to Piero della Francesca. Should any doubt remain that the Cortona altarpiece was planned before Angelico's next documented work, the Linaiuoli triptych, it can be set at rest by comparing the panels of the *Adoration of the Magi* in the centre of the two predellas. In the frieze-like *Adoration of the Magi* at Cortona the Virgin is seated on the right and the three Kings and their retinue are spread across the scene. In the Linaiuoli triptych, on the other hand, the composition is circular; the Virgin is seated on the right with two of the Magi kneeling in the foreground, and St. Joseph is shown in conversation with the third Magus behind. The notion that the Cortona panel could have been evolved after that of the Linaiuoli triptych runs counter to everything we know of Angelico's development.

The project for the triptych commissioned by the Arte dei Linaiuoli, or guild of flax-workers, for the Residenza of the guild in Piazza Sant'Andrea dates back to October 1432, when a wooden model for the tabernacle was prepared to the design of Ghiberti. A contract for the painting destined for the tabernacle, to be painted 'inside and out with gold, blue and silver of the best and finest that can be found', was awarded to Angelico on 2 July 1433, at a cost of 'one hundred and ninety gold florins for the whole and for his craftsmanship, or for as much less as his conscience shall deem it right to charge'. Its content was to correspond with a drawing, presumably prepared by the artist. The frame, with its arched central aperture, dictated the form of the painting, which consists of a central panel of the Virgin and Child enthroned between two mobile wings. On the inside of the wings (and therefore visible only when the triptych was open) are figures of the two Saints John; on the outside (and therefore visible only when the triptych was closed) are Saints Peter and Mark, scenes from whose legends are illustrated in the predella beneath.

If the Linaiuoli triptych were shown today in the Uffizi, and not in the Museo di San Marco, its exceptional size would register more strikingly; among panel

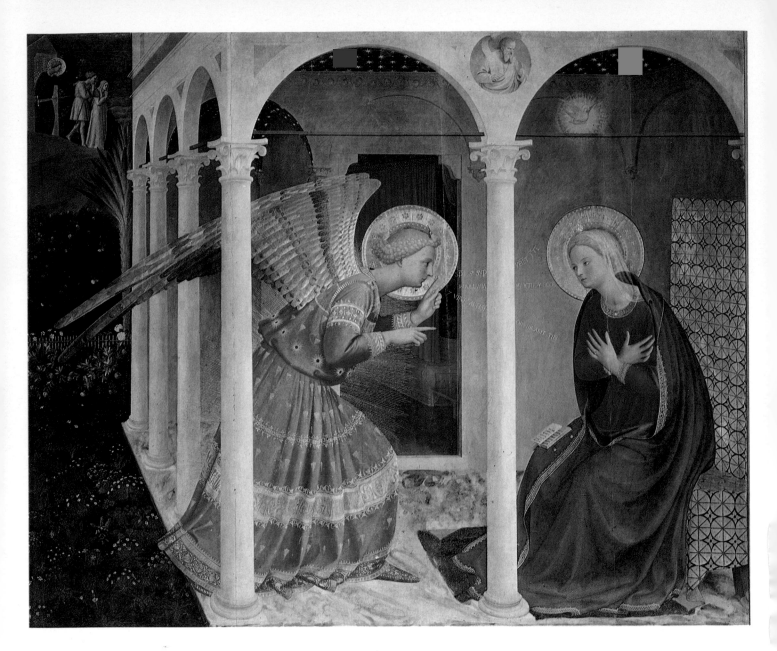

paintings it would be comparable only with Cimabue's high altarpiece from Santa Trinita and Duccio's *Rucellai Madonna*. In the first document relating to the tabernacle there is a reference to the position it was to occupy 'dove oggi è dipinta la figura di nostra donna'; and it may well be that the size of the tabernacle, and therefore of the painted panels, was determined by some dugento *Madonna* which they replaced. The scale of the four saints on the wings is greater than that of any other Florentine panel painting of the time. How then is Angelico's success in rendering them to be accounted for? The most likely explanation is that Ghiberti played a part in the designing not only of the frame but of the triptych as a whole. There is indeed a passage in the *Commentari* which may refer to this commission, in which Ghiberti describes the assistance he gave to painters and sculptors by providing them with models in wax and clay, and continues: 'etiandio chi avesse avuta affare figure grandi fuori del naturale forma, [ho io] dato le regole a condurle con perfetta misura'. The saints in the wings are an equivalent in painting for the statues of

Annunciation
c 1432-3
175x180 cm
Museo Diocesano, Cortona.
The Annunciation originally stood in the church of San Domenico at Cortona. It was moved to the Gesù in the nineteenth century and later installed in the Museo Diocesano.

(above right)
Expulsion from Paradise, detail from the Cortona Annunciation.

(right)
Visitation, from the predella of the Cortona Annunciation.

guild patrons on Or San Michele. Particularly striking is the calculated tri-dimensionality of the four figures, the Baptist, whose cross is held forward of his body, St. John the Evangelist, who extends his right hand in benediction and in his left holds a volume of the Gospels with its edge turned to the spectator, St. Mark, whose pose is established by the diagonals of the feet and of the foreshortened book, and St. Peter, whose volume of epistles is supported by both hands, the right held slightly forward of the body and the left thrust outwards beneath his cloak. The two inner figures may indeed be regarded as pictorial transcriptions of Ghiberti's *St. Matthew* and *St. Stephen*, and the outer figures as examples of the statues Ghiberti might have produced had he continued to practise as a monumental sculptor after 1429. The space structure of the much damaged central panel, however, proceeds logically from the painter's earlier works. At the bottom is a receding platform, which is boldly aligned on the front plane and has as its counterpart at the top a star-strewn roof like that in the Washington *Annunciation* of Masolino. The panel is surrounded by a wooden frame decorated with twelve music-making angels, which have become the most popular figures in Angelico's whole oeuvre. They are designed with greater freedom than the angels in the earlier works — so much so that we might once again suspect the intervention of Ghiberti — but are so much damaged that it is difficult to judge whether they were painted by Angelico or by a studio hand.

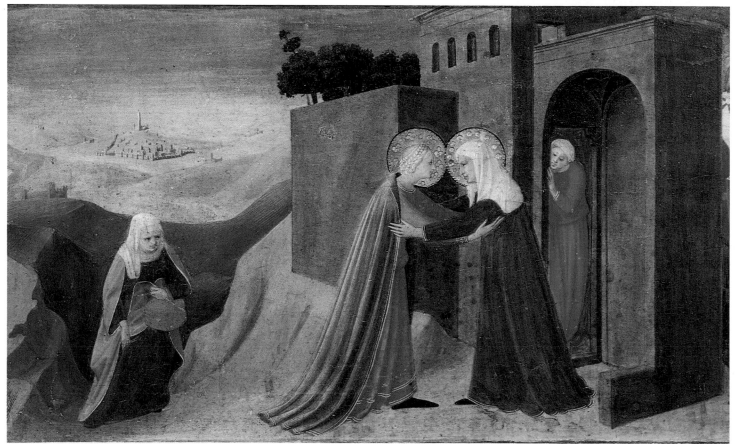

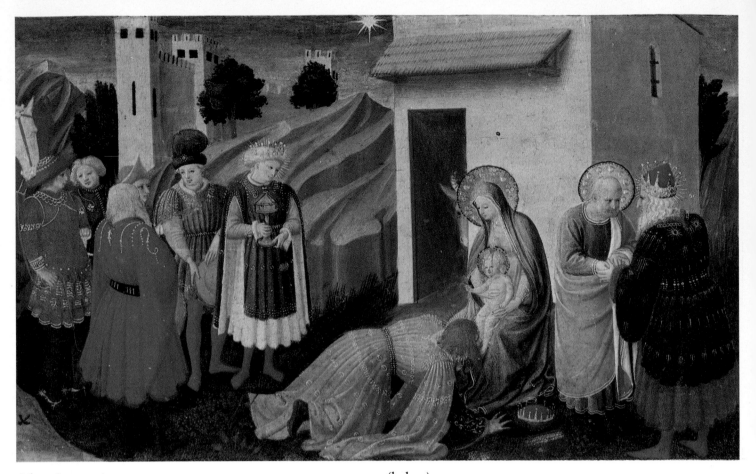

(above)
Adoration of the Magi, from the predella of the Cortona Annunciation.

(below)
Adoration of the Magi, from the predella of the Linaiuoli Tabernacle.

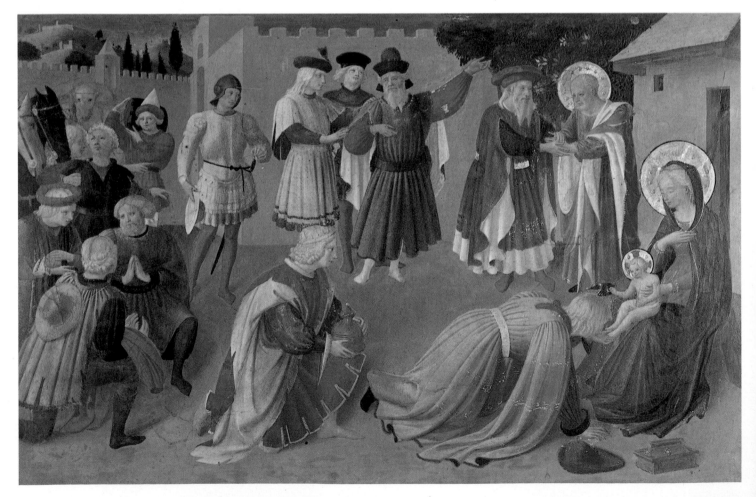

Linaiuoli Tabernacle
1433-5
260x330 cm
Museo di San Marco,
Florence.

What we do not know about the Linaiuoli triptych is the year in which it was installed, but if, as is likely, the main panels occupied Angelico for about two years, work on the predella may have been begun only in 1434 or 1435. The subject of the first panel is not the scene of St. Peter exhorting the faithful depicted by Masolino in the Brancacci Chapel but St. Peter dictating the Gospel of St. Mark. In the centre St. Peter preaches from an hexagonal wooden pulpit, and at the left in profile sits St. Mark taking down his words, with the assistance of a kneeling acolyte, who holds an ink-horn, and of two scribes, who carry the completed manuscript. The type of the Saint Peter seems to contain a conscious reference to the Saint Peter of Masaccio, and the realistic figures in profile framing the composition at the sides likewise recall the lateral figures of the *Saint Peter enthroned and the Raising of the Son of Theophilus* in the Brancacci Chapel. The spatial thrust is deeper than in any previous scene, and the buildings at the sides and in the background are more carefully defined. This too must be due to study of Masaccio. The corresponding panel on the right shows the body of St. Mark dragged in a hailstorm through the streets of Alexandria. Nothing in the artist's earlier work prepares us for this incomparably vivid scene. The figures are portrayed in violent action, with a repertory of gesture on which Angelico, when he came a few years later to portray the legend of Saints Cosmas and Damian in the San Marco altarpiece, made little significant advance; and one of them, the youth with arm raised pulling the body of the Saint, once more recalls Gentile da Fabriano. Still more remarkable is the depiction of the hailstorm and the lowering sky seen over the wall, which have a partial equivalent in Siena in Sassetta's *Miracle of the Snow* but none in Florentine painting. At the time he was working on these panels, in the middle fourteen-thirties, Angelico's must have been the most frequented Florentine studio — its only competitor was that of Fra Filippo Lippi — and it is thither that young artists like Piero della Francesca and Domenico Veneziano would have gravitated when they arrived in Florence. In the central panel of the Linaiuoli predella indeed there is one head, of a youth beside two horses, whose upturned face and flaxen hair suffused with light are painted with a pointilliste technique that is unlike Angelico's and could well be due to the young Piero.

Linaiuoli Tabernacle with the wings closed showing Saints Peter and Mark.

(above right)
Saint Peter dictating the Gospels of Saint Mark, from the predella of the Linaiuoli Tabernacle.

(below right)
Martyrdom of Saint Mark, from the predella of the Linaiuoli Tabernacle.

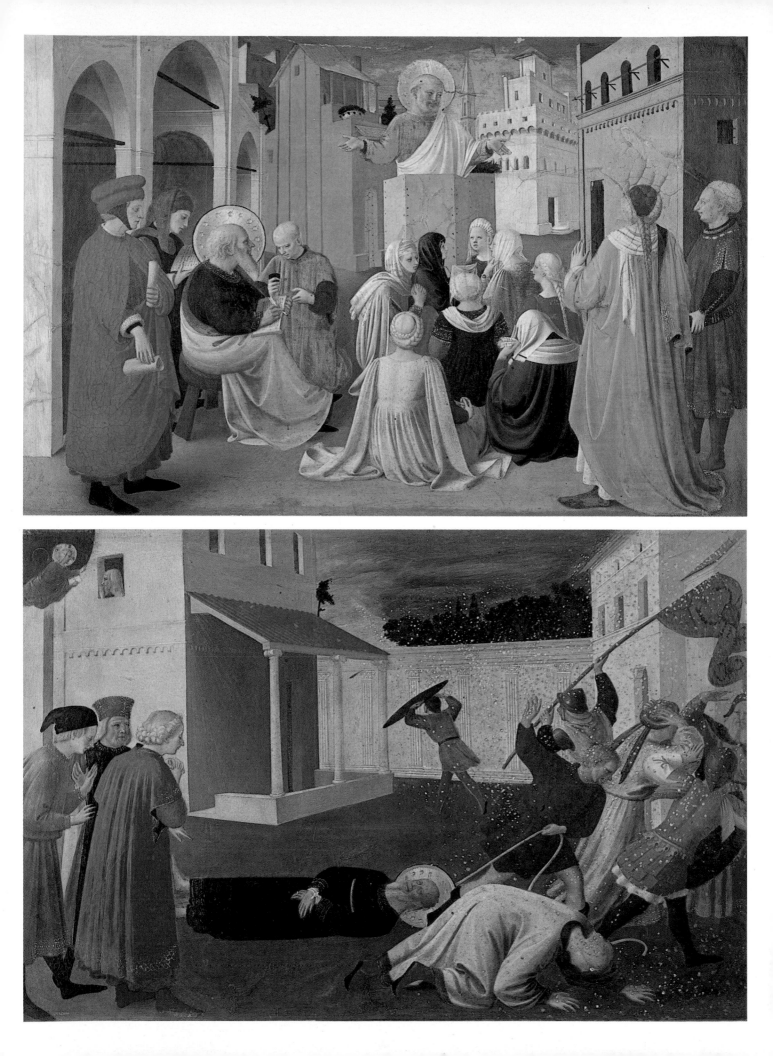

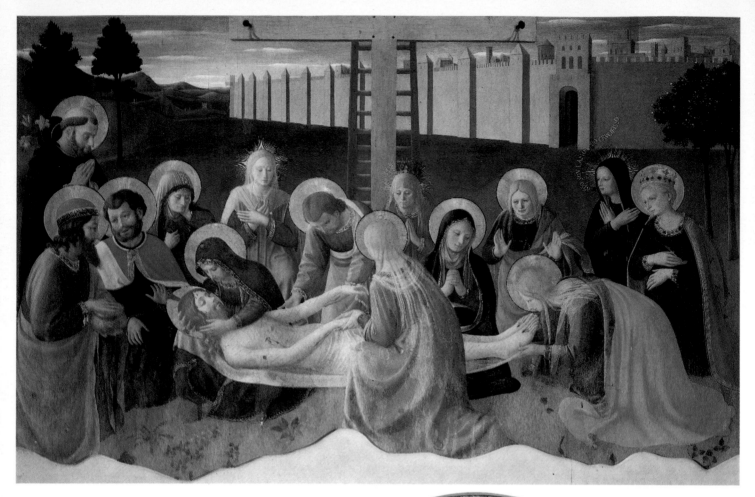

Lamentation over the dead Christ
1436
105x164 cm
Museo di San Marco, Florence

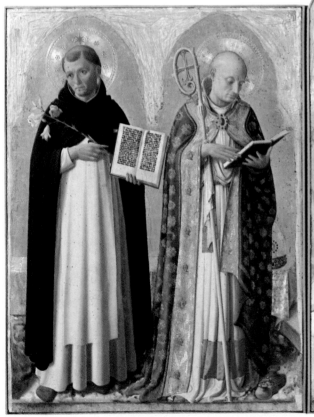

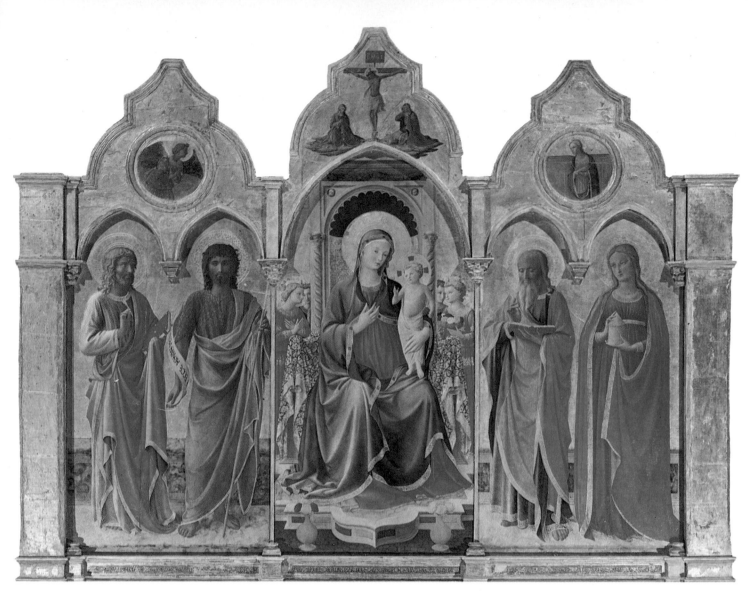

Virgin and Child Enthroned with Saints John the Evangelist, John the Baptist, Mark (?) and Mary Magdalen
c 1436
218x240 cm
Museo Diocesano, Cortona.
Painted for the church of San Domenico in Cortona.

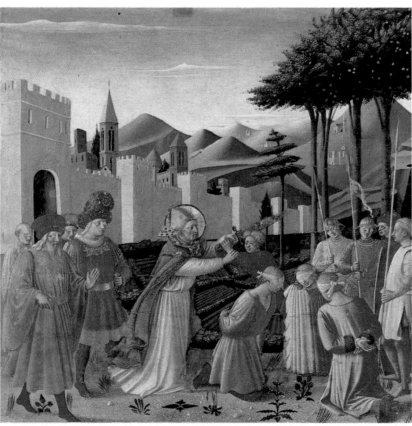

(left)
Virgin and Child Enthroned with Saints Dominic and Nicholas of Bari
1437
Galleria Nazionale dell'Umbria, Perugia.
The centre and left-hand panels from the altarpiece painted for the church of San Domenico in Perugia.

(right)
Saint Nicholas saves three men condemned to execution, from the predella of the Perugia polyptych.
Galleria Nazionale dell'Umbria, Perugia.

Angelico's next dated work is of a very different character. It is a painting of the *Lamentation over the dead Christ*, now in the Museo di San Marco, commissioned for the confraternity of Santa Maria della Croce al Tempio in April 1436 and completed in December of the same year. The donor, Fra Sebastiano di Jacopo Benintendi, was a nephew of the Beata Villana de' Botti, over whose relics the Confraternity held certain rights. According to a life of the Beata Villana extracted by Razzi from a volume of biographies of the Saints and Beati of the Dominican Order, she ardently aspired to share the sufferings of Christ, her celestial spouse, and 'in her visions had always before her mind the image of her Jesus Christ, beaten and crucified, whose torments she wished to emulate'. She is seen kneeling on the right, with the words CRISTO IESV LAMOR MIO CRVCIFISSO issuing from her mouth. Some of the figures are of inferior quality, but Angelico alone could have painted the elegiac landscape on the left. The long wall of the city of Jerusalem recalls the distant view of Florence on the right of Ghiberti's *Miracle of Saint Zenobius*.

From the following year, 1437, dates a polyptych painted for the chapel of St. Nicholas in the church of San Domenico at Perugia, now in the Galleria Nazionale dell'Umbria. Dismantled before the middle of the nineteenth century, its panels were later reintegrated in a modern frame; they are now shown unframed. Those parts that are autograph, the Virgin and Child in the centre and the fine figures of Saints Dominic and Nicholas of Bari on the left-hand side, are less monumental than the comparable figures of the Linaiuoli tabernacle. The St. John the Baptist and St. Catherine of Alexandria on the right are largely studio work. In the solidly constructed throne and the table covered with a cloth which runs behind each pair of Saints the artist attempts for the first time to escape from the tyranny of the gold ground. The predella panels are unlike those of the Linaiuoli tabernacle in that the scale of the figures is reduced. In the first panel, with the birth of St. Nicholas and St. Nicholas and the three maidens, the effect is a trifle tentative, but in the third, with St. Nicholas saving three men condemned to execution and the death of the Saint, the vanishing point of the city wall depicted on the left falls in the centre of the panel and the perspective of the chamber on the right converges on the friar behind the bier. By one of those strokes of sheer pictorial genius with which Angelico so often surprises us, the two scenes are illuminated from a common source, which irradiates the figures on the left and floods into the chamber on the right-hand side.

The qualitative standard by which the Perugia polyptych must be judged is established by an altarpiece painted for San Domenico at Cortona a year or two before, probably in 1436. Its form, a Gothic polyptych with pointed panels, remains faithful to that of the Fiesole high altar. The painting was transferred from its original wood panels in 1945, exposing in the process the underdrawing beneath. All the underdrawing is by a single hand and yields valuable information on the way in which Angelico's panels were built up. In each the forms are sketched in *terra verde* on the priming, the linear features, hair, eyelids, lips and nostrils being indicated with great refinement and subtlety. While the main areas of light and shadow are established, the volume of the completed figures is no more than hinted at. Not unnaturally the process of completion involved some coarsening of the linear qualities of the cartoon. In those figures that are autograph it is clear that Angelico himself deliberately sacrificed some of the delicacy of the initial image to recession and solidity.

The dilution of quality in the Perugia altarpiece and to a less extent in the polyptych at Cortona reflects the pressure under which the workshop at Fiesole was operating at this time. It was producing small autograph paintings, like the predella panel of the *Naming of the Baptist* in the Museo di San Marco where the figure style is strongly Ghibertesque. It was producing small paintings that are not autograph, like the three reliquary panels from Santa Maria Novella, now in the Museo di San Marco, which were painted for Fra Giovanni Masi before 1434. It was producing more substantial paintings, in which Angelico was responsible for the cartoons, but which were carried out with studio assistance. One of these is the beautiful *Coronation of the Virgin* in the Uffizi, which was painted about 1435 for Sant'Egidio and had as its predella two panels of the *Marriage* and *Dormition of the Virgin* in the Museo di San Marco. If we imagine these paintings drawn out by Angelico with the same exactness as the figures on the Cortona polyptych, and coloured partly by the artist and partly by assistants, we can understand readily enough why their execution is so unequal.

More important for our knowledge of Angelico are the frescoes which he executed for San Domenico at Fiesole at this time. Two of them, a *Virgin and Child with Saints Dominic and Thomas Aquinas*, formerly in the dormitory, and a *Christ on the Cross adored by Saint Dominic with the Virgin and Saint John*, formerly in the refectory, are now in Leningrad and Paris. A somewhat similar fresco of the *Virgin and Child with Saints Dominic and Peter Martyr* was painted by Angelico over the portal of San Domenico at Cortona, probably about 1438. In the history of conventual decoration the paintings from Fiesole mark a new departure in idiom and iconography. They are free from distraction and devoid of decorative accidentals, and in two of them the spectator, in the person of the founder of the Dominican order, participates in the holy scene. Presented with the minimum of incident, they are designed to be filled out by the religious imagination of the onlooker, and represent the first stage in the evolution of an art which was calculated to stimulate and to enrich the community's spiritual life.

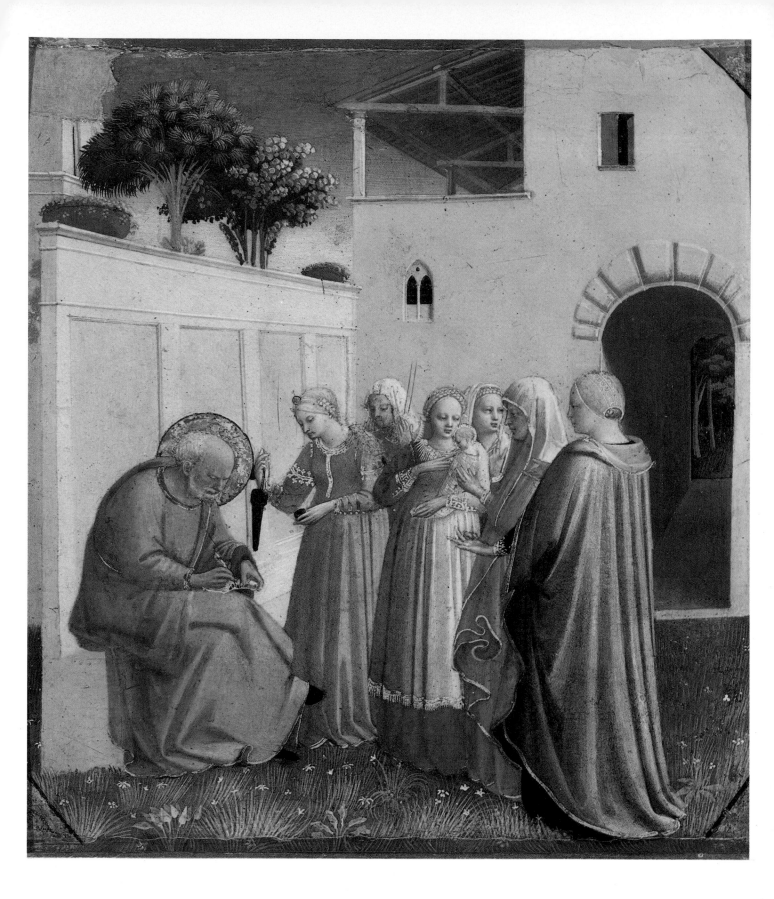

Naming of Saint John the Baptist
26x24 cm
Museo di San Marco, Florence.
Part of the predella from an unidentified altarpiece, certainly
painted before 1435.

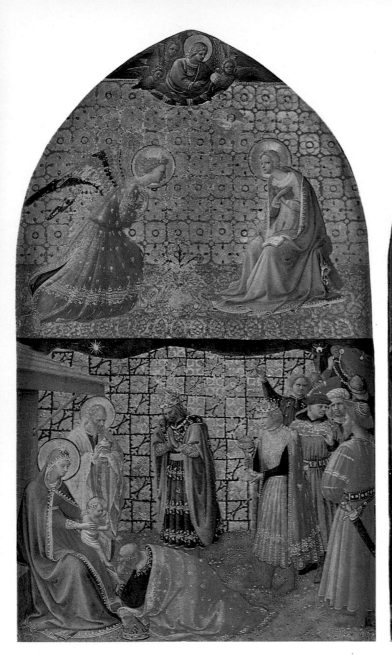

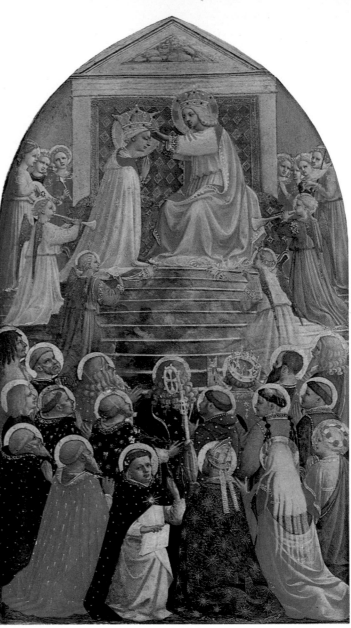

Annunciation and Adoration of the Magi
42x25 cm

Coronation of the Virgin
42x25 cm

Madonna della Stella
60x30 cm

These three reliquary panels in the Museo di San Marco, together with a fourth in the Isabella Stewart Gardner Museum, Boston, were painted in Angelico's workshop for Fra Giovanni Masi, sometime between 1430 and 1434.

Coronation of the Virgin
c 1435
112x114 cm
Uffizi, Florence.

Marriage of the Virgin
19x50 cm

Dormition of the Virgin
19x50 cm

These panels, in the Museo di San Marco, once comprised the predella of the Uffizi Coronation.

(overleaf)
Christ on the Cross adored by Saint Dominic
c 1435
435x260 cm
Louvre, Paris

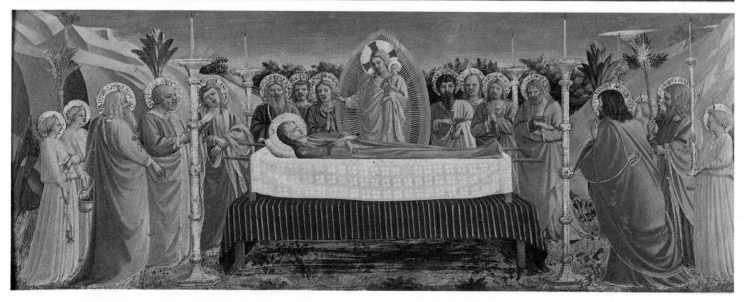

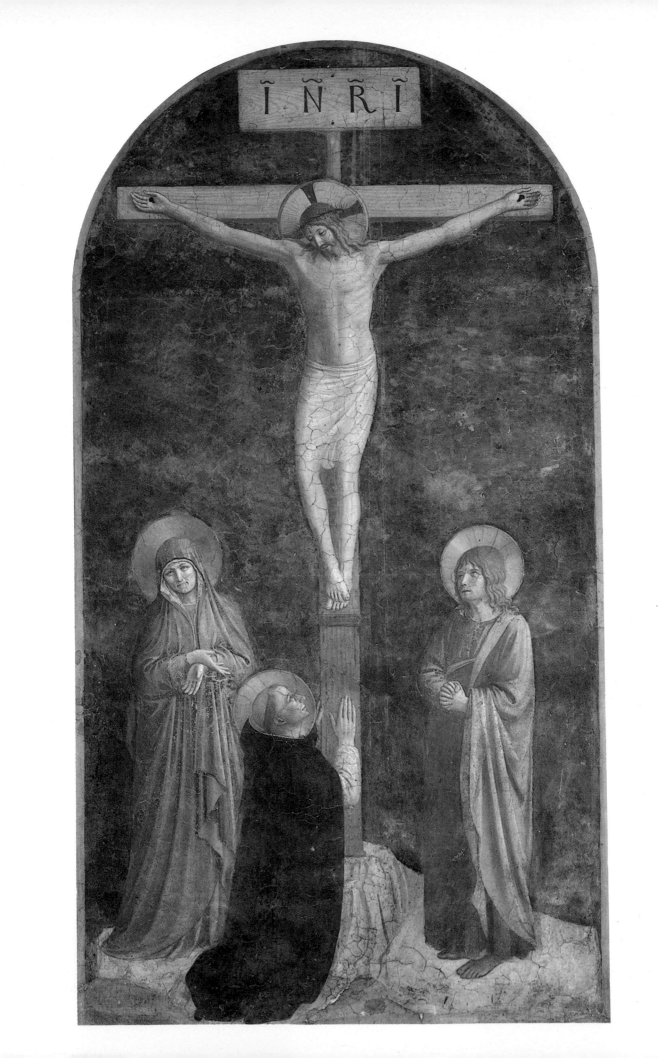

Frescoes at San Marco

The recall of Cosimo de' Medici to Florence in 1434 opened a new chapter in the history of the Dominican Observants at Fiesole. As early as 1420 Cosimo had exercised his patronage in favour of the reformed Franciscan convent of Bosco ai Frati, and two years after his return he obtained the assent of the Pope, Eugenius IV, then resident in Florence, to the requisitioning and handing over to the Observant Dominican community of the Silvestrine convent of San Marco. When the Dominicans took over the premises, the convent buildings were in ruins, and only the church was structurally sound. Since the Dominican title to the convent was contested by the Silvestrine community, rebuilding did not start till 1437, and for two years the friars were housed in damp cells and wooden huts. When the Council of Basle at length confirmed the Dominican claim to the convent, the task of reconstruction was begun, and from this time on work was pressed forward at the commission of the Medici by the architect and sculptor Michelozzo. The sequence of the buildings can be established with a fair measure of certainty from the *Cronaca di San Marco* compiled by Giuliano Lapaccini, a companion of Angelico who received the habit of the order at Fiesole in 1433 and in 1444 became Prior of San Marco. In 1439 the *cappella maggiore* of the church was finished, and by 1442 the church was ready to be dedicated. The convent premises were rebuilt at the same time. In 1438 twenty cells in the central dormitory over the refectory were rebuilt or repaired, and by 1443 all the cells on the upper floor, to a total of forty-four, were fit for habitation. Structural work in one part of the building or another continued until 1452. Close contact must have been maintained between Angelico and Michelozzo during the years in which the convent was being built. The fruits of this are to be found in the convent frescoes, where the settings depend for their effect upon the same unerring use of interval as do the cloister and library of Michelozzo.

Describing the most notable features of the convent Lapaccini mentions the Library (conspicuous alike for its great length and for its thirty-two benches of cypress wood), the residential buildings (so harmonious, yet so convenient), and the garden, and goes on: 'A third feature is the paintings. For the altarpiece of the high altar and the figures in the Sala del Capitolo and the first cloister and all the upper cells and the Crucifixion in the refectory are all painted by the brother of the Dominican Order from the convent at Fiesole, who had the highest mastery in the art of painting in Italy. He was called Brother Johannes Petri de Mugello, and was a man of the utmost modesty and of religious life'. The frescoes on the ground floor of the convent comprise a *Christ on the Cross adored by Saint Dominic* and five lunettes in the cloister and a large *Crucifixion with attendant Saints* in the Sala del Capitolo. A fresco of the *Crucifixion* in the refectory was destroyed in 1554. On the first floor there are three frescoes in the corridor (a *Christ on the Cross adored by Saint Dominic*, an *Annunciation*, and a *Virgin and Child with Saints*) and forty-three frescoes in the forty-five cells opening off it. All the frescoes on the ground floor are wholly or partly by Angelico. On the extent of his responsibility for the remaining frescoes a wide variety of views have been expressed, and at one time or another he has been charged with as many as forty-one and as few as six of the narrative scenes. The *Cronaca di San Marco* proves beyond all reasonable doubt that as early as 1457 (the terminal date for the completion of the chronicle) Angelico was credited with the entire fresco decoration of the convent as it then stood. But this view is sanctioned neither by examination of the frescoes nor by common sense, for the execution of so many frescoes in so short a time was beyond the capability of a single artist, and the frescoes themselves reveal the presence of three or four main hands. That the class of frescoes in the cells was ideated by Angelico and that Angelico himself supervised the decoration of the convent is not open to doubt, but the frescoes for which he was directly responsible are vastly outnumbered by the scenes in which assistants were charged with executing his cartoons, or which were conceived by his disciples within the framework of his style.

The *Scenes from the Life of Christ* which decorate the cells follow no natural sequence. Frescoes whose subjects are inter-related are sometimes separated by the whole length of the corridor. The frescoes in the eleven cells on the east side of the corridor represent the *Noli Me Tangere*, the *Entombment*, the *Annunciation, Christ on the Cross with four Saints*, the *Nativity*, the *Transfiguration*, the *Mocking of Christ*, the *Resurrection*, the *Coronation of the Virgin*, the *Presentation in the Temple*, and the *Virgin and Child with two Saints*. With the exception of a fresco of the *Adoration of the Magi* in Cell 39 on the north-west corner of the building (which is considerably larger than the other cells, and was occupied by Cosimo de' Medici, Pope Eugenius IV, and

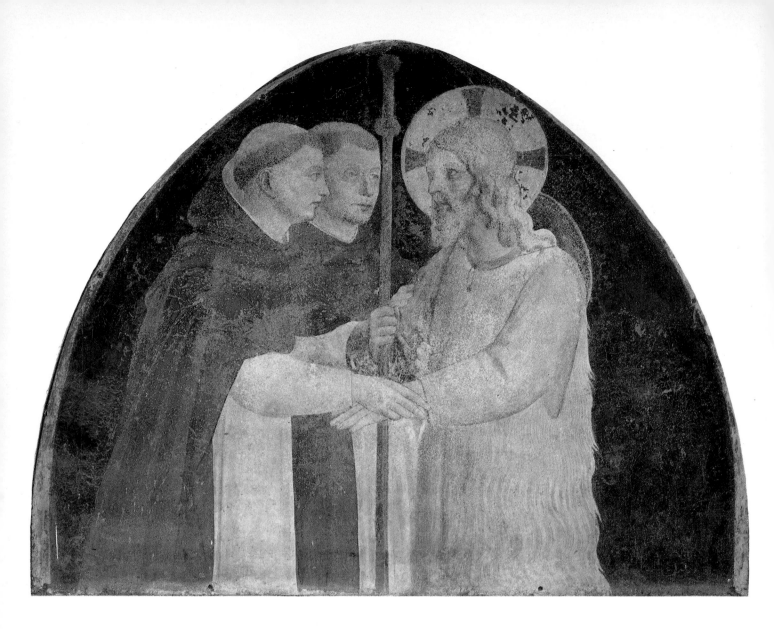

Christ as Pilgrim received by two Dominicans
c 1442
Cloister, San Marco, Florence.

other distinguished visitors to the convent), these include the only frescoes in the cells for which a direct attribution to Angelico is warranted. Even these scenes vary appreciably in quality, but applying criteria based on his other works, we may credit Angelico with the design and execution of the *Noli Me Tangere* in Cell 1, the *Annunciation* in Cell 3, the *Transfiguration* in Cell 6, the *Mocking of Christ* in Cell 7, the *Coronation of the Virgin* in Cell 9, and the *Presentation in the Temple* in Cell 10. The frescoes in Cells 2, 4, 5, 8 and 11 are by a single hand, the Master of Cell 2. All these five frescoes were executed under the general direction of Angelico, who possibly supplied small drawings for certain of the figure groups (the *Entombment* is a case in point), but was not responsible for the cartoons. An indication of the close association that must have existed between Angelico and his disciple is afforded by the presence in the *Maries at the Sepulchre* in Cell 8 of an angel's head painted by Angelico. The Master of Cell 2 seems to have been a member of the master's studio from the mid-thirties on, and was responsible for executing parts of the Croce al Tempio *Lamentation* and of the *Deposition* from Santa Trinita.

(right)
Christ on the Cross adored by Saint Dominic
c 1442
Cloister, San Marco, Florence.

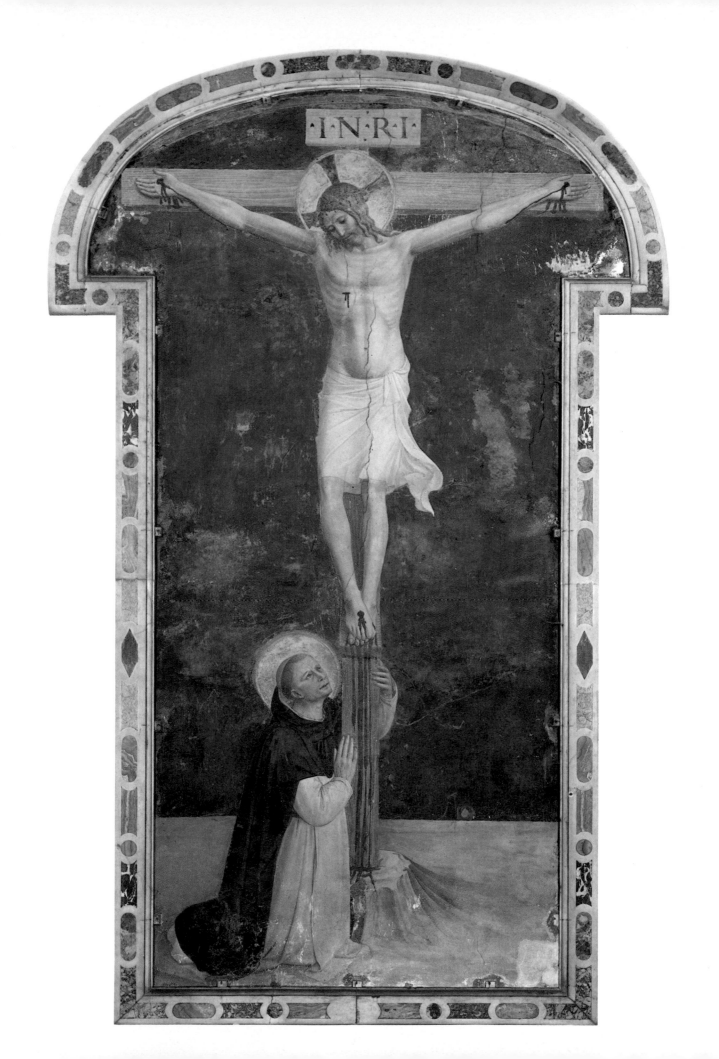

The frescoes in the cells on the inner side of the corridor overlooking the cloister are greatly inferior to the frescoes in the outer cells. Cells 15 to 23 (which housed members of the novitiate and were therefore of relatively little consequence) contain figures of *Christ on the Cross adored by Saint Dominic*, which depend from the frescoes of this subject by Angelico in the cloister beneath and by a studio assistant in the corridor; these are seemingly the work of a single artist, and maintain a level of undistinguished competence. They are followed, in Cells 24, 25, 26 and 27, by four scenes (the *Baptism of Christ, Christ on the Cross*, the *Man of Sorrows* and the *Flagellation*), which are almost certainly by the Master of Cell 2, but are less closely indebted to Angelico than the frescoes opposite. A fresco of *Christ carrying the Cross* in Cell 28 is by another hand, and the *Crucifixion* in Cell 29 is by Benozzo Gozzoli. Turning the corner, along the north side of the cloister, we come to six scenes by a single hand (*Christ in Limbo*, the *Sermon on the Mount*, the *Arrest of Christ,* the *Temptation of Christ,* the *Agony in the Garden* and the *Institution of the Eucharist*), where the loose grouping and curvilinear compositions are at variance with the frescoes in the earlier cells. Passing to Cells 36, 37 and 42, we find a *Christ nailed to the Cross* and two frescoes of the *Crucifixion with attendant Saints*, in which the style and spirit, if not the handling, once more conform to Angelico's intentions in the autograph frescoes. The author of these scenes followed Angelico to Rome in 1445, and was employed in the upper cycle of frescoes in the Vatican. He is likely to be identical with one of the secondary artists listed in 1447 as members of the painter's Roman studio.

We do not know in what year the frescoes at San Marco were begun. From 1437 or 1438 Angelico's principal concern lay with the altarpiece for the high altar of the church, a work of great elaboration which reveals scarcely the least trace of studio assistance. If the altarpiece was finished only in 1440 or 1441, the painting of the frescoes may have started after this time. The single fixed point is that the large *Crucifixion* in the Sala del Capitolo seems to date from 1441-2. The fresco on the upper floor most closely related to it, the *Adoration of the Magi* in Cell 39, is likely also to date from 1442. The conjectural sequence which would most readily reconcile the style testimony of the frescoes with the known facts is that the first to be carried out were those in Cells 1 to 11, some of which are by Angelico and some of which were executed by a close assistant under his supervision. These may date from 1440-1. Thereafter the main focus of interest was the Sala del Capitolo, followed by the *Adoration of the Magi*. The frescoes in Cells 24 to 28, in which Angelico did not participate, may have been painted at this time. The frescoes over the doorways of the cloister, for which Angelico was himself responsible, seem to follow the *Crucifixion* in the Sala del Capitolo, and are in turn followed by what is probably the latest of Angelico's pre-Roman frescoes, the *Christ on the Cross adored by Saint Dominic* on the north wall of the cloister. There is no evidence whatever for the dating of the frescoes in Cells 31 to 37, and no indication whether they were executed before 1445,

Crucifixion with attendant Saints
1441-2
550x950 cm
Sala del Capitolo,
San Marco, Florence.

Detail of the Holy Women,
from the Crucifixion.

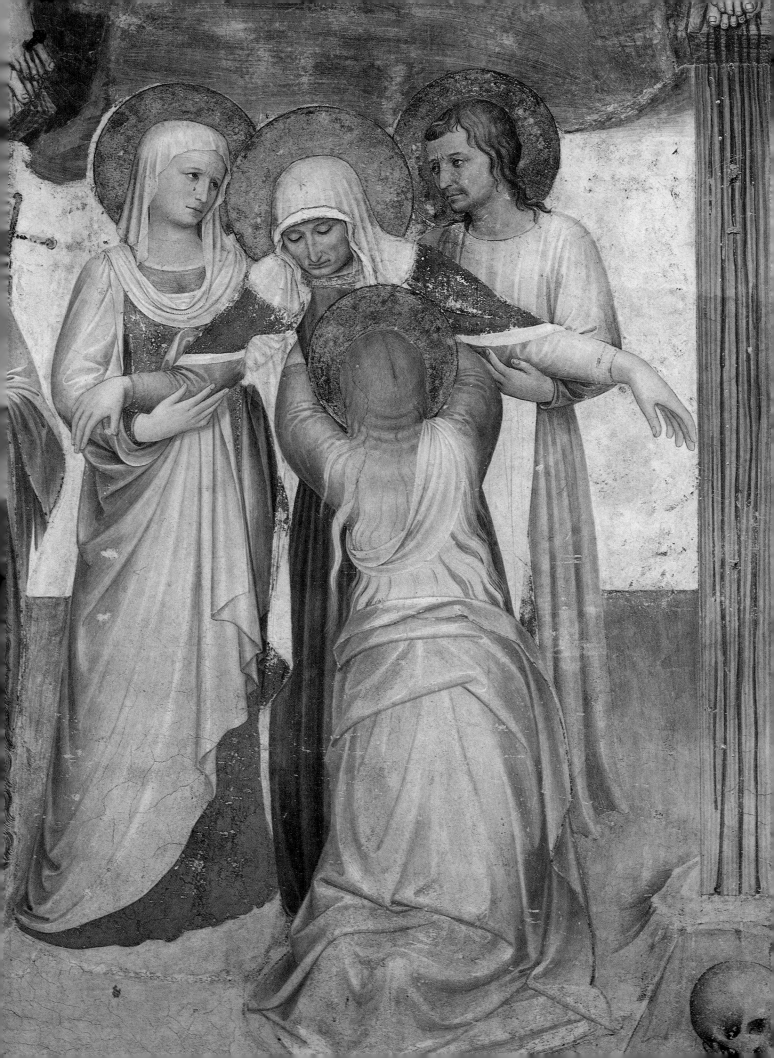

when Angelico was still in Florence, or after that year, when he was in Rome. Two frescoes in the upper corridor, the *Virgin and Child with Saints* and the *Annunciation*, are later in style than the remaining frescoes, and were probably painted in 1450 after his return.

The largest fresco in the cloister, that opposite the entrance, shows *Christ on the Cross adored by Saint Dominic*. Developed from the fresco from Fiesole in the Louvre, where the Saint is shown in profile and a less explicit and emotional relation is established with the figure on the Cross, it establishes the central theme of the frescoes on the upper as well as on the lower floor, the mystical participation of members of the Dominican Order, personified by the figure of their founder, in the life and sufferings of Christ. The shape of the fresco field was changed in the seventeenth century, when an irregular marble surround was added to it. By comparison with the fresco from Fiesole, the body of Christ is modelled more richly and with a new naturalism and tactility. The five lunettes in the cloister are in poor condition. Four of them, the *Saint Peter Martyr* enjoining silence above the entrance to the sacristy, the much abraded *Saint Dominic* holding out his rule, the *Saint Thomas Aquinas* with the *Summa* open on his breast, and the *Christ as Man of Sorrows*, are distinguished principally for their sense of volume and for the masterly placing of the figures on their grounds. The fifth, above the doorway of the hospice, shows *Christ as Pilgrim received by two Dominicans*. The lunettes, like the *Crucifixion* in the Louvre, are surrounded by carefully constructed illusionistic frames.

A work of greater intrinsic importance is the *Crucifixion* in the Sala del Capitolo. This large arched fresco fills the entire north wall of the room. Its programme emerges from the pages of Vasari, who relates how Angelico was instructed by Cosimo de' Medici 'to paint the Passion of Christ on a wall of the chapterhouse. On one side are all the saints who have founded or been heads of religious orders, sorrowful and weeping at the foot of the Cross, the other side being occupied by St. Mark the Evangelist, the Mother of God, who has fainted on seeing the Saviour of the world crucified, the Maries who are supporting her, and Saints Cosmas and Damian, the former said to be a portrait of his friend Nanni d'Antonio di Banco, the sculptor. Beneath this work, in a frieze above the dado, he made a tree, at the foot of which is St. Dominic; and in some medallions, which are about the branches, are all the popes, cardinals, bishops, saints and masters of theology who had been members of the Order of the Friars Preachers up to that time. In this work he introduced many portraits, the friars helping him by sending for them to different places'. Like the Croce al Tempio *Lamentation*, the fresco at San Marco is a mystical representation of the Crucifixion and not a narrative scene. The figures of the crucified Christ, the women beneath the Cross, and the attendant saints (on the left Saints Cosmas and Damian, Lawrence, Mark and John the Baptist, on the right

Plan of the cells in the convent of San Marco

1. Noli Me Tangere
2. Entombment
3. Annunciation
4. Crucifixion
5. Nativity
6. Transfiguration
7. Mocking of Christ
8. Resurrection
9. Coronation of the Virgin
10. Presentation in the Temple
11. Virgin and Child with two Saints
12-14. Cells of Savonarola
15-23. Christ on the Cross adored by Saint Dominic
24. Baptism of Christ
25. Christ on the Cross
26. Man of Sorrows
27. Flagellation
28. Christ carrying the Cross
29. Crucifixion
30. Crucifixion
31. Christ in Limbo
32. Sermon on the Mount
32a. Arrest of Christ
33. Temptation of Christ
33a. Entry into Jerusalem
34. Agony in the Garden
35. Institution of the Eucharist
36. Christ nailed to the Cross
37. Crucifixion
38. Crucifixion
39. Adoration of the Magi
40-44. Crucifixion
a. Annunciation (page 70)
b. Christ on the Cross adored by Saint Dominic
c. Virgin and Child with Saints (page 70)

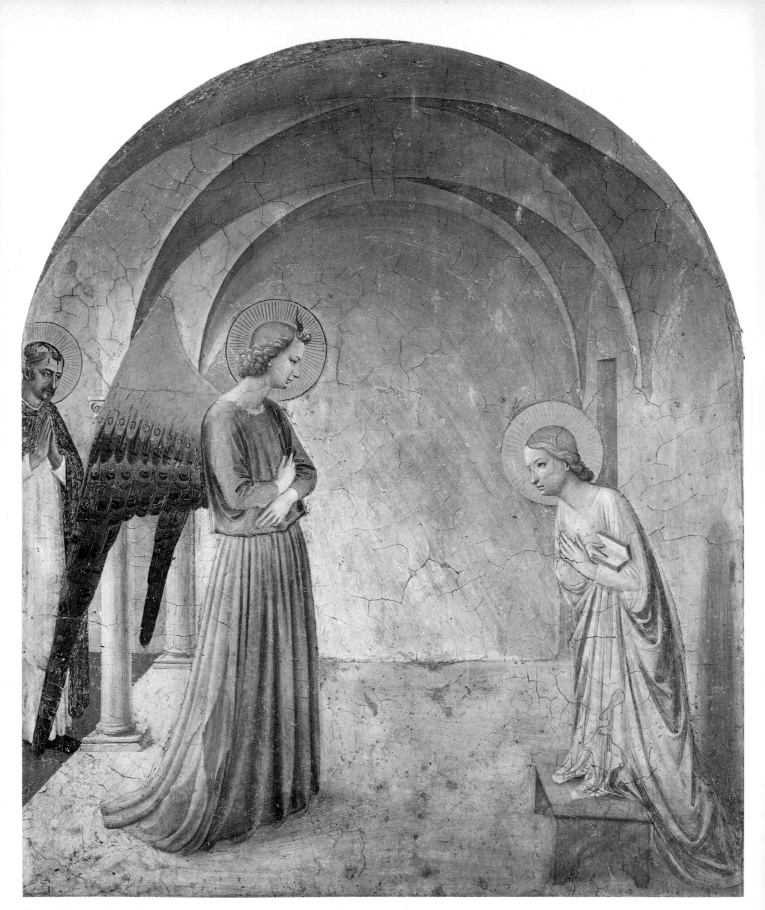

Saints Dominic, once more kneeling beneath the Cross, Ambrose, Jerome, Augustine, Francis, Benedict, Bernard, Giovanni Gualberto, Peter Martyr and Thomas Aquinas) are ranged along the front plane of the painting, and the single intimation of space is in the crosses of the two thieves, which recede diagonally into the dark ground. The vertical shaft of the Cross divides the fresco

Annunciation
1440-1
187x157 cm
Upper floor, cell 3, San Marco, Florence.

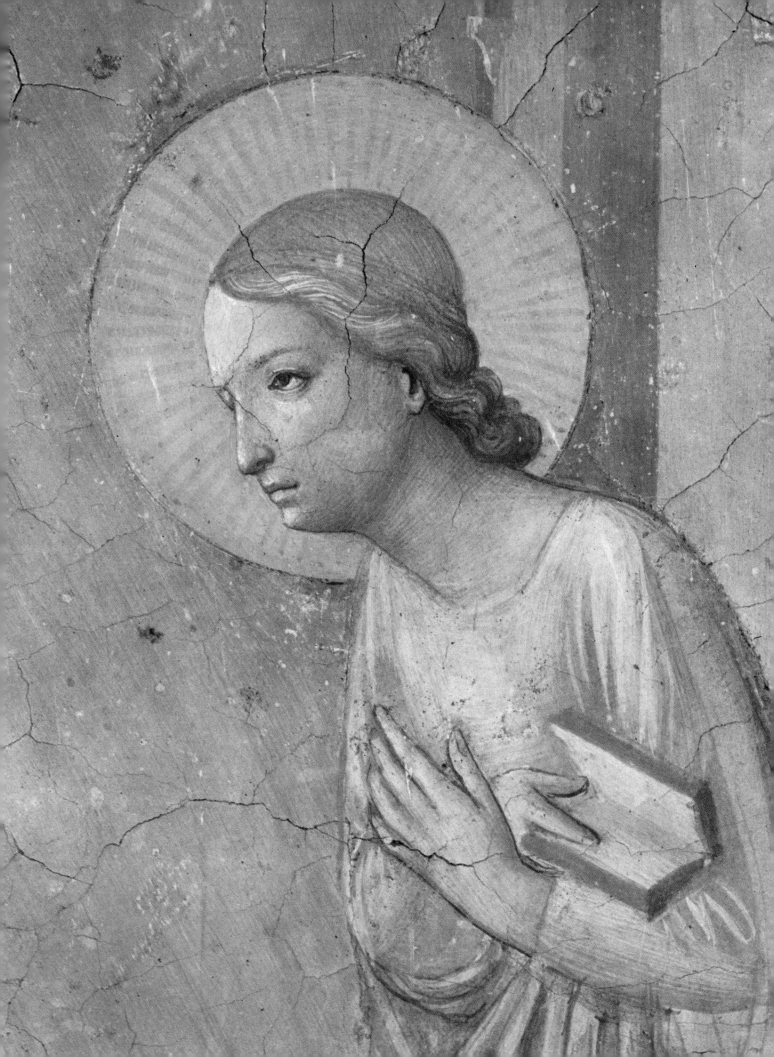

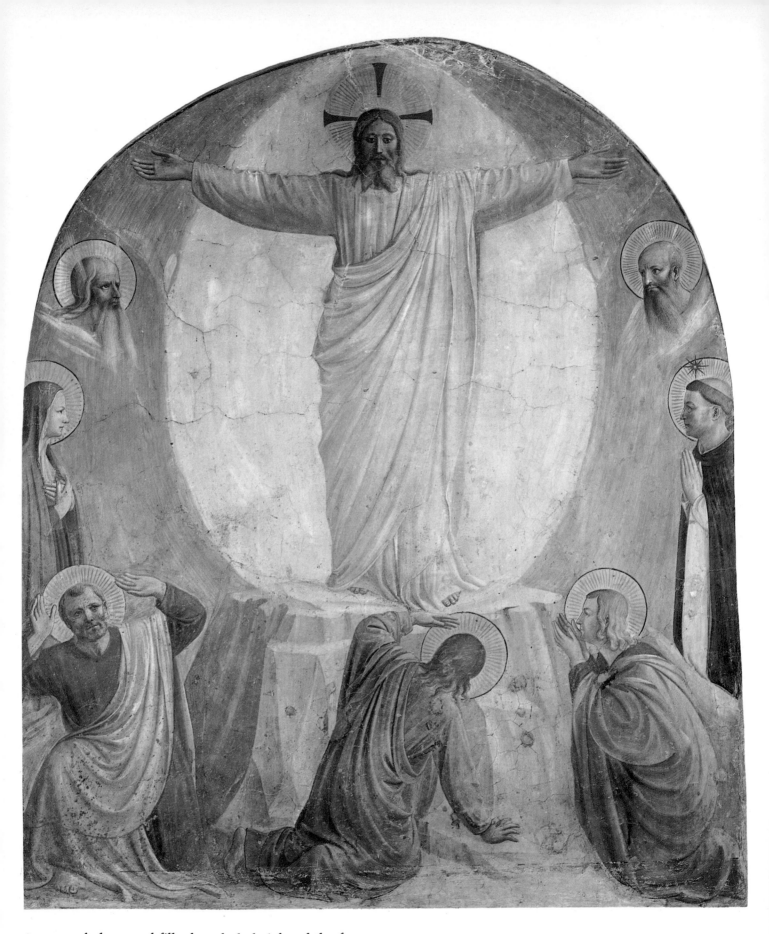

into two halves, and fills the whole height of the fresco field. The theme of the painting is elaborated in inscriptions on the scrolls held by the prophets in the decorative border surrounding the scene. Among these are the VERE LANGORES NOSTROS IPSE TVLIT ET DOLORES NOSTROS of Isaiah, the O VOS OMNES QUI

Transfiguration
1440-1
189x159
Upper floor, cell 6, San Marco, Florence.

38

TRANSITE PER VIAM ATTENDITE SI EST DOLOR SICUT DOLOR MEUS of Jeremiah, and the QVIS DET DE CARNIBVS EIVS VT SATVREMVR of Job. An impressive exposition of an intellectual concept, the *Crucifixion* is not one of Angelico's most successful paintings, and owing in part to its condition (the original blue ground has been removed, leaving the figures like cut-out silhouettes on the restored red underpainting) and in part to the weight of its didactic scheme, it remains a manifesto which falls short of a great work of art.

Those who know the frescoes in the cells upstairs only from photographs miss their essential character. In

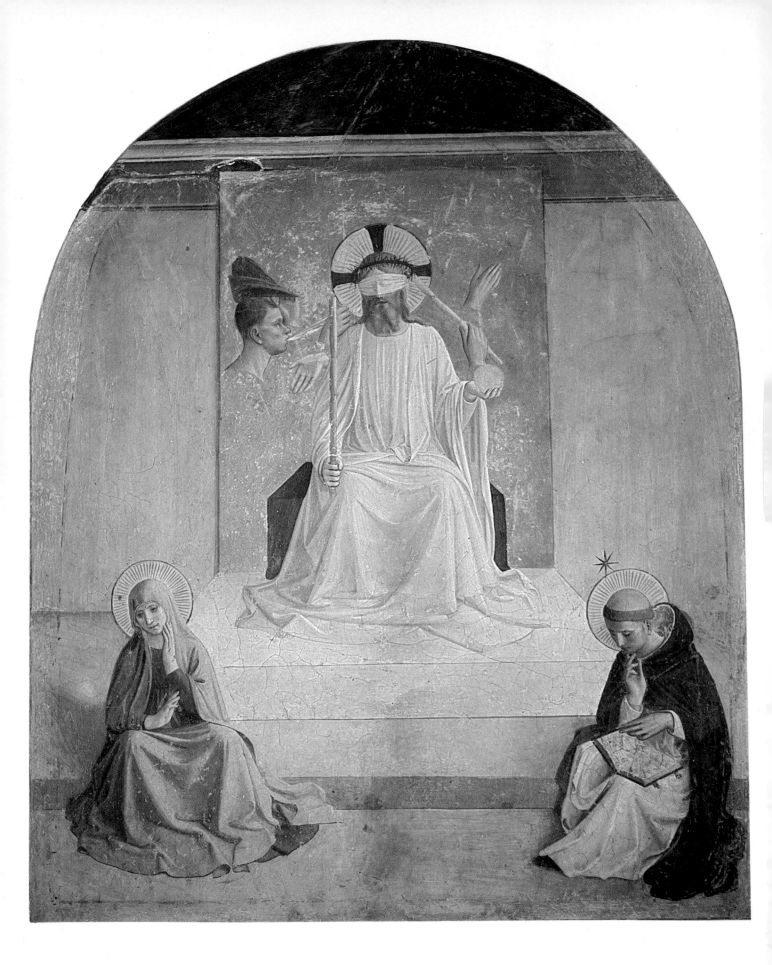

Mocking of Christ
1440-1
195x159 cm
Upper floor, cell 7, San Marco, Florence.

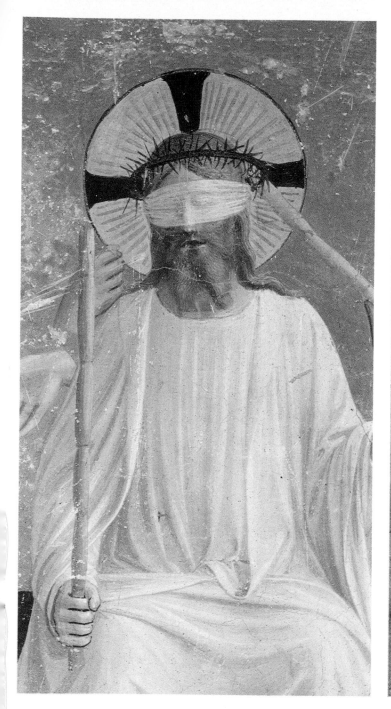

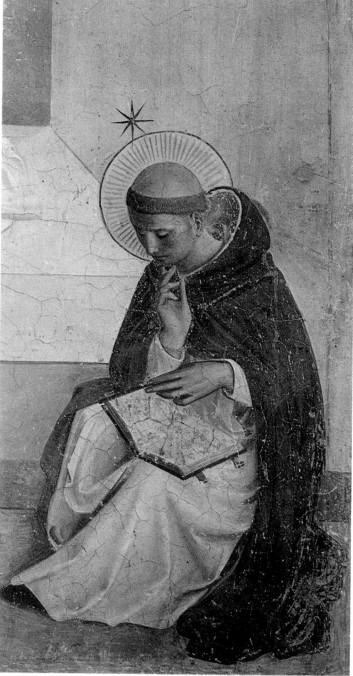

relation to the rooms in which they find themselves, most of the scenes (and all of those associable with Angelico) are relatively large in scale. In each case the scene is represented on the window wall opposite the door, and the wall thus contains two apertures, one opening on the physical and the other on the spiritual world. Dominating their austere surroundings, they were designed as aids to meditation, not as decoration, and were intended to secure for the mysteries they described a place in the forefront of the friar's mind by keeping them constantly before his eyes. In this respect they form a spiritual exercise. The cursory examination of the frescoes which we make as we walk from cell to cell today is the exact opposite of the use for which they were designed. At Fiesole the frescoed decoration of the convent seems to have been confined to public rooms, and we do not know to whom the decision to extend this

decoration to the cells occupied by individual friars was due. Perhaps its instigator was Fra Cipriano, the first prior of San Marco, perhaps Sant'Antonino, who recommends the contemplation of devotional pictures as one of the reasons why the faithful should pay frequent visits to a church. But it is indicative of Angelico's contribution to this conception that the simplest and sparsest of the frescoes in the cells are those for which he was responsible, while those in which he had no hand revert, by some process of natural attraction, to the norm of fresco painting.

One of the finest of the autograph frescoes on the upper floor is the *Annunciation* in the third cell. Here almost all the characteristic features of the *Annunciation* at Cortona and of the paintings based on it are abandoned in favour of a composition of the utmost

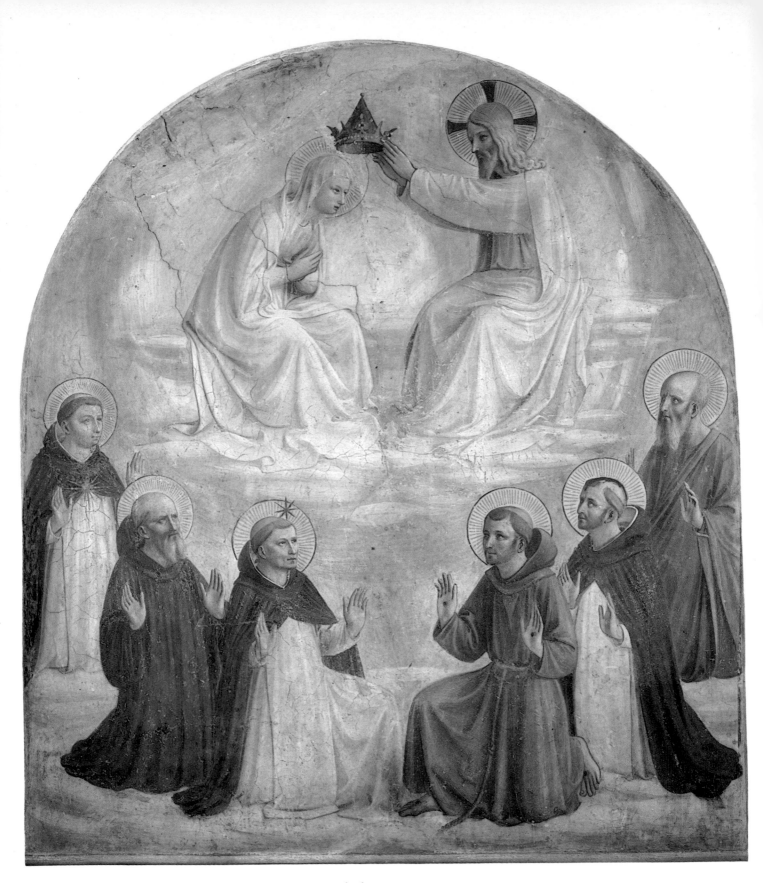

severity. Instead of the Brunelleschan loggia of the earlier painting, with its garden and doorway leading into another room, it depicts a cell-like chamber closed by a blind wall, which has the double function of providing a background for the figures and of discouraging the mind from straying from the confines of the scene. It is characteristic of a tendency to eliminate extraneous detail that even the capitals of the two columns are covered by the angel's wings. Alberti in his

Coronation of the Virgin
1440-1
189x159 cm
Upper floor, cell 9, San Marco, Florence.

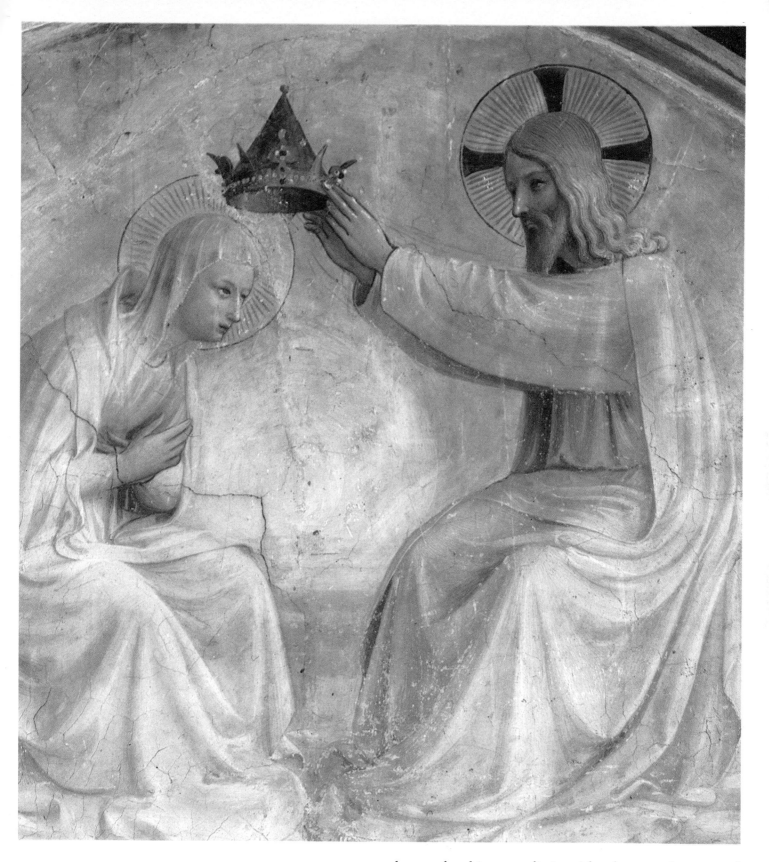

theory of architecture distinguishes between beauty and ornament, the one deriving from a system of harmonious proportion, the other consisting of the columns and other ancillary decorative features of the building. Angelico's consistent avoidance in the frescoes in the cells of architectural features which Alberti would have considered ornamental, and his rigid adherence to a system of visual harmony, suggests that at San Marco he may have had some such distinction in mind. The

Michelozzan vaulting above, realised with the finality of an abstract pattern, is not the least beautiful aspect of the fresco. In the figures the intimation of movement which contributes so much to the appeal of the earlier altarpiece is put aside, and the Virgin and Angel are treated like a sculptured group, restrained and motionless.

The *Noli Me Tangere* in the first cell follows the same compositional procedure as the *Annunciation*. Once again the visual interest of the scheme depends on the relation between two figures in repose, and once again a flat surface, in this case a wooden paling, is used to isolate the head of the main figure. In the foreground is a plethora of minutely observed and carefully rendered flowers, grasses and trees. This scene is the only one of Angelico's cell frescoes into which there obtrudes the interest in nature that we find in the *Deposition* altarpiece and other panel paintings. The sixth cell brings us to what is in some respects the greatest of the frescoes, the *Transfiguration*, where the majestic figure of Christ, with arms outstretched in a pose prefiguring the Crucifixion, is outlined against a wheel of light. Beneath this splendid sculptural figure, there crouch the three apostles in poses instinct with astonishment and awe. The heads of Moses and Elias beneath the arms of Christ illustrate very clearly the strength of modelling of which Angelico was capable. The *Mocking of Christ* shows the central figure seated, again in full face, against a rectangle of curtain, on which are depicted the symbols of his suffering. This use of emblematic iconography, for which precedents occur in the trecento, may have been dictated by the wish to avoid violent action and strong narrative interest in these frescoes. Few forms in the frescoes are realised with greater sureness and accomplishment than the white robe of Christ. Seated on a low step in the foreground are the contemplative figures of the Virgin and St. Dominic. The *Coronation of the Virgin* in the ninth cell is strikingly at variance with Angelico's earlier paintings of this theme, for the act of coronation is performed not, as in the painting in the Uffizi and the reliquary panel at San Marco, before a host of onlookers, but in isolation, with six kneeling saints who proclaim, but do not assist in, the main scene. Apart from these frescoes stands the much-restored lunette of the *Adoration of the Magi* in Cell 39. In design and handling this fresco is more closely related to the *Crucifixion* in the Sala del Capitolo than to the frescoes in the cells. Not only are the figures once more deployed in a frieze along the front plane of the painting, but certain of them seem to have been executed by the same assistant who was responsible for parts of the larger scene. This assistant has been plausibly identified with the young Benozzo Gozzoli. A number of the poses used in the *Adoration* are anticipated in the predella of the San Marco altarpiece, and both the elaborate, studied composition and the light, decorative palette of the fresco are more secular in spirit than those in the frescoes in the other cells.

Presentation in the Temple
1440-1
151x131 cm
Upper floor, cell 10, San Marco, Florence.

Below, before restoration.
Right, after restoration.

A campaign of restoration in the cells of the upper floor at San Marco, currently (1981) in progress, has uncovered the original splendour and intensity of Angelico's frescoes. His colours have proved brighter and of more subtle disposition than could have been imagined before cleaning, while the spatial content and the strength of modelling in the autograph scenes has become more than ever apparent, further accentuating the qualitative difference between the frescoes executed by Angelico and those done, entirely or in large part, by his assistants. The most dramatic change appeared in the cleaning of the Presentation in the Temple. Its repainted red background was removed, re-establishing the intervals of space between the figures and exposing the original architectural background of the scene, with a flaming altar between the Virgin and Saint Simeon. The figures of Saint Peter Martyr, the Beata Villana and the Infant Christ had been repainted before the middle of the nineteenth century, and have emerged as autograph creations of Fra Angelico.

(overleaf)
Saint Simeon with the Infant Christ, detail of the Presentation in the Temple, after restoration.

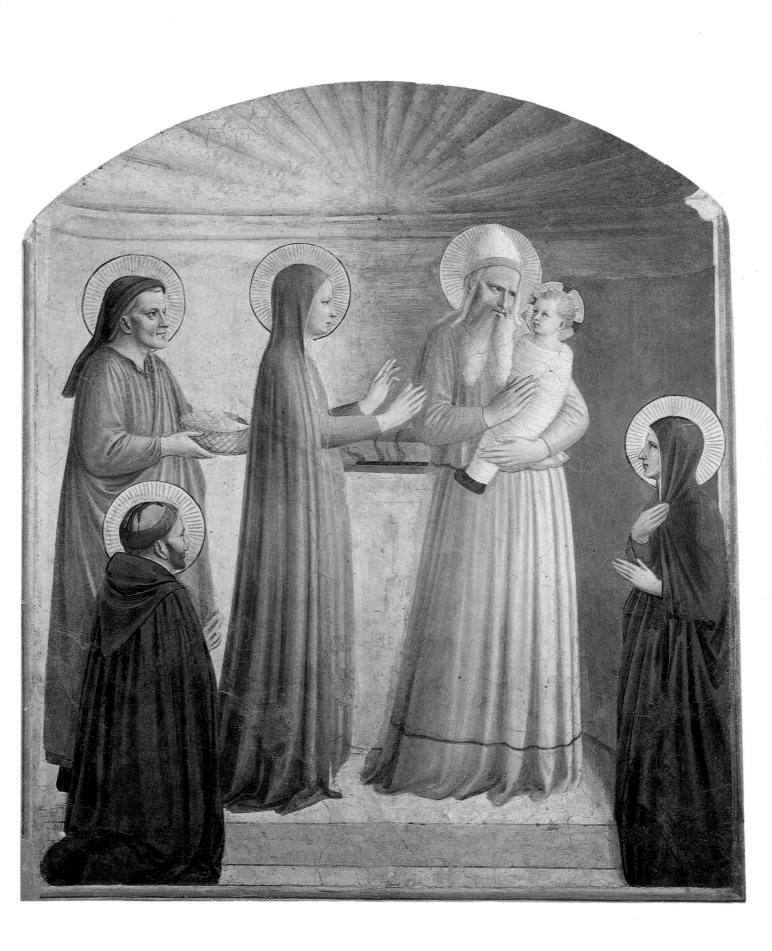

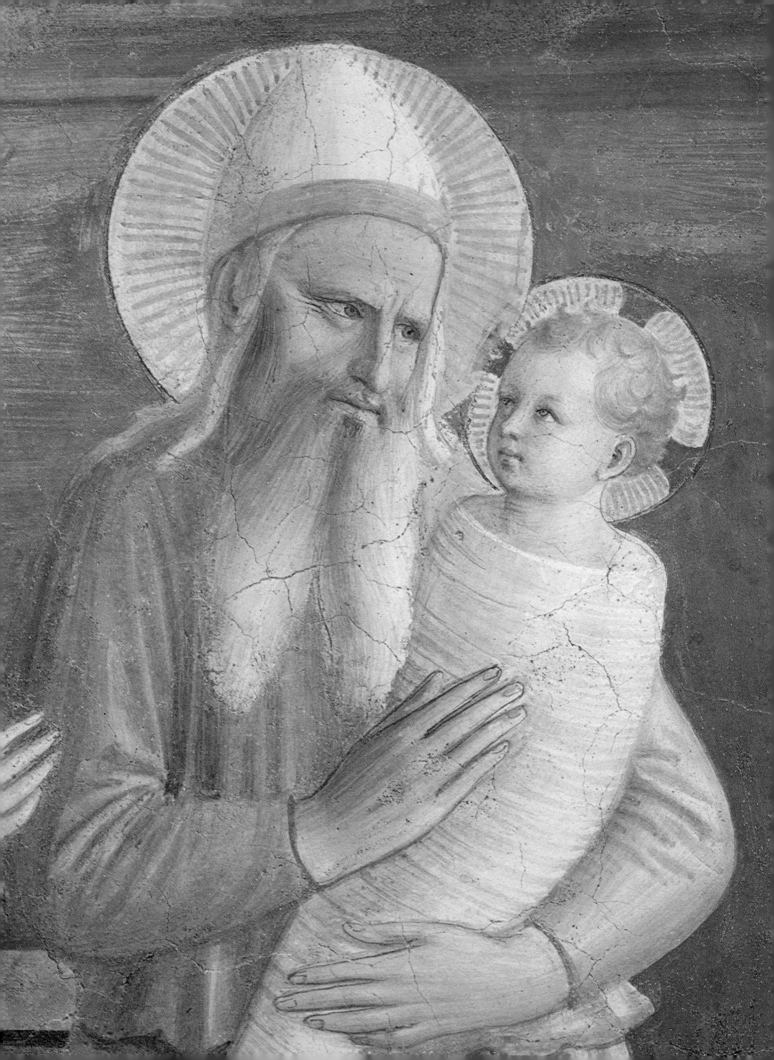

Panel Paintings
1438-45

The Dominican take-over at San Marco was by no means a simple operation. In addition to the Silvestrine claim to the convent, which was disallowed, a certain Mariotto de' Banchi exercised rights over the high altar and tribune of the church. In 1438 an arrangement was made whereby these were made over to the chapter and convent of San Marco, and were then presented by the community to Cosimo and Lorenzo de' Medici, who in turn paid a sum of five hundred ducats to the original owner. The Medici saints, Cosmas and Damian, were associated with St. Mark as titularies of the high altar. On the old altar there stood an altarpiece of the *Coronation of the Virgin* painted in 1402 by Lorenzo di Niccolò with a predella containing scenes from the lives of St. Mark and St. Benedict. It was agreed in 1438, at the instance of the Prior, Fra Cipriano, that this should be transferred to the convent of San Domenico at Cortona as a gift from Cosimo de' Medici, and in 1440 it was installed there, with the names of the Medici donors inscribed on it. The new high altarpiece was entrusted to Fra Angelico, presumably in 1438 when the decision was taken to do away with the old altar, and was not finished ('necdum perfecta erat') in 1440 when the old altar was moved. It must, however, have been completed before Epiphany 1443, when the church and high altar were dedicated, in the presence of Eugenius IV, by the Archbishop of Capua.

A letter written to Piero de' Medici by the young Domenico Veneziano in April 1438 refers to an altarpiece of great splendour which Cosimo was commissioning at that time. The passage reads: 'I have heard just now that Cosimo is determined to have executed, that is painted, an altarpiece, and requires magnificent work. This news pleases me much, and would please me still more if it were possible for you to ensure through your magnanimity that I painted it. If this comes about, I hope in God to show you marvellous things, even considering that there are good masters, like Fra Filippo and Fra Giovanni, who have much work to do'. In view of the coincidence of date, it is very possible that this letter refers to the San Marco altarpiece. Whether it does or not, there is abundant evidence that the commission was regarded as one of exceptional significance. Not only was it a Medicean manifesto, the most important commission for a painting placed by Cosimo de' Medici up to that time, it was also the cynosure of the principal Dominican Observant church in Florence. It had, moreover, one other unusual aspect,

that the architectural setting for which it was destined was under construction at the time the altarpiece was planned. The picture, or rather the complex of paintings, that resulted was a truly revolutionary work.

There are two impediments to an appreciation of the painting. The first is that a number of devices which appear in it for the first time were copied in many later paintings. The carpet in the foreground and the figures kneeling on it recur in the San Giusto alle Mura altarpiece of Ghirlandaio. The line of cypresses and palm trees seen at the back behind the wall was imitated by Baldovinetti in the Cafaggiolo altarpiece in the Uffizi. The looped gold curtains, which enclose the foreground like a proscenium arch, were adopted by Raffaellino del Garbo and Verrocchio. As we look at the main panel we have forcibly to remind ourselves that when it was conceived these expedients were original. The second impediment is that of physical condition; at some time in the past the surface was cleaned with an abrasive, and it is very difficult today to form a clear impression of its drawing, lighting or tonality. What is immediately apparent is that its spatial content is greater than that of any previous altarpiece. Whereas the *Madonna* of the Linaiuoli triptych fills a deep cupboard in the centre of the painting and the Saints in the Perugia polyptych are fortified by the presence of a table at the back which divorces them from their gold ground, in the San Marco altarpiece monumental use is for the first time made of advanced constructional principles. It is projected from a high viewing point, roughly in the centre of the panel, and the orthogonals of the beautifully rendered Anatolian carpet and the steep perspective of the cornice of the throne converge to a vanishing point in the main group. The recession of the unprecedentedly extensive foreground is established by the diminishing pattern of the carpet and by Saints Cosmas and Damian, who kneel in the front plane, one directing his gaze to the spectator and the other facing towards the Child. The planes which separate them from the throne are demarcated by three figures on each side, on the left St. Lawrence with hand raised in wonder and Saints John the Evangelist and Mark in conversation, and on the right St. Francis praying in profile between Saints Peter Martyr and Dominic. In the middle distance, in front of a gold-brocaded curtain, are set the Virgin and Child, flanked by four angels at each side. Behind the angels runs a wall covered with woven fabric, over which we see two palm trees and a grove of cedars and cypresses and between their trunks what must have been the most beautiful of

San Marco Altarpiece
1438-40
220 x 227 cm
Museo di San Marco, Florence.

Saint Cosmas, detail from the San Marco Altarpiece.

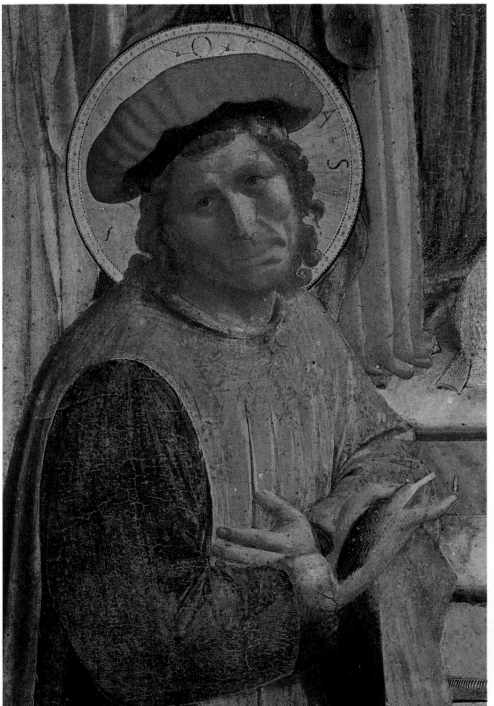

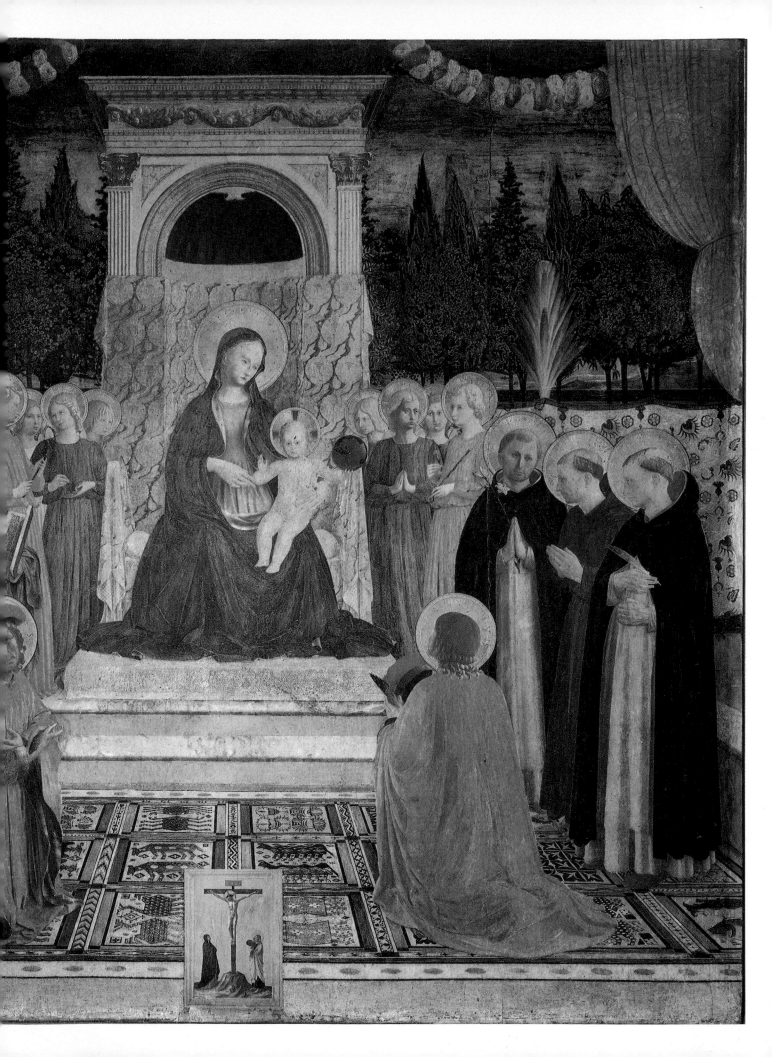

Saints Cosmas and Damian and their Brothers before Lycias
38x45 cm
Alte Pinakothek, Munich.
From the predella of the San Marco Altarpiece.

Angelico's landscapes. Though the perspective devices are unostentatious — much more so than in the emphatic shallow structure of contemporary paintings by Fra Filippo Lippi like the *Coronation of the Virgin* in the Uffizi and the Barbadori altarpiece in the Louvre — they achieve a continuum of space greater than that in any earlier altarpiece. Of the lighting which once softened and unified the figures no more than a faint indication survives.

Two other aspects of the painting deserve mention. The first (which is best analysed by a Dominican scholar) is its programme. The volume of the Gospels held by St. Mark is open at Chapter VI, 2-8, which begins with the description of Christ teaching in the synagogue, and how his auditors 'were astonished, saying, From whence hath this man these things? And what wisdom is this which is given unto him, that even such mighty works are wrought by his hands?', and which close with an injunction to the apostles 'that they should take nothing for their journey save a staff only; no scrip, no bread, no money in their purse'. On the left, two of the saints reflect the astonishment of Christ's hearers in the synagogue, and opposite are representatives of the two ord-

(right)
Decapitation of Saints Cosmas and Damian
36x46 cm
Louvre, Paris.
From the predella of the San Marco Altarpiece.

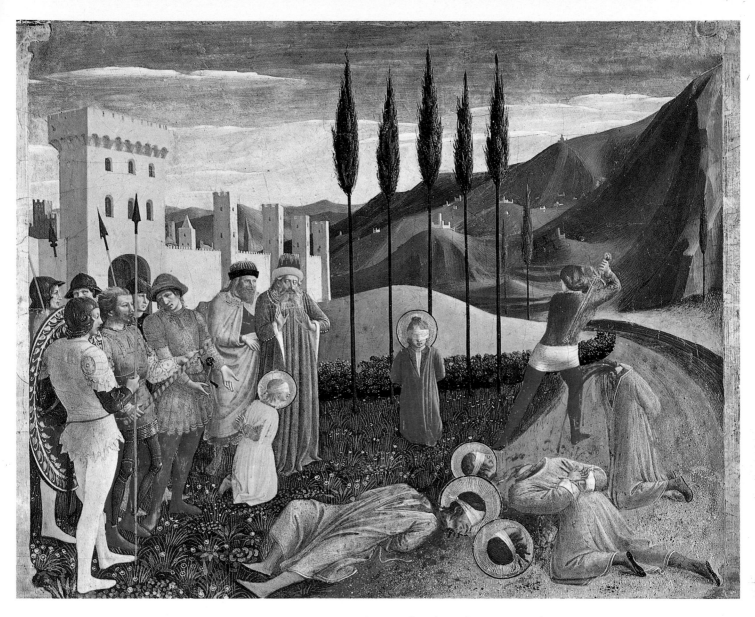

ers which observed the rule of apostolic poverty. Round the edge of the Virgin's robe is a quotation from *Ecclesiastes*, and *Ecclesiastes* is again the source of the palmtrees, cedars and cypresses at the back and of the rose garlands which hang behind the curtains at the front. The second aspect of the altarpiece that should be noted is its highly charged emotional character. The only area in which some impression of this can still be gained is the head of Saint Cosmas, which strikes a note of pathos that is absent from earlier Renaissance paintings. Its implications are underlined in the small *Crucifixion* at the base, which originally surmounted the central panel of the predella with the *Lamentation over the dead Christ.*

The artistic complexion of the altarpiece can be read more clearly in the predella panels, of which all but the first, the *Healing of Palladia by Saints Cosmas and Damian* in Washington, are well preserved. Probably the panels were painted in the sequence in which they stood on the altar, the *Saints before Lycias*, the *Lycias Possessed by Devils*, and the *Crucifixion of Saints Cosmas and Damian* in Munich, and the *Attempted Martyrdom of Saints Cosmas and Damian by Fire* in Dublin following the panel in Washington. At this time Angelico mastered

or developed a system of projection more consistent and more advanced than that used in his earlier works. The device of a flat surface parallel with the front plane of the painting is an indispensable feature of the panels. In the *Decapitation of Saints Cosmas and Damian*, it is established not by architecture, but by a row of cypress trees. The distant city on the left recalls that in the St. Nicholas predella at Perugia, but since the scene is lit from the right not from the left, those faces of the wall which were in shadow in Perugia are brightly lit and those faces which were illuminated are in shadow. Structurally the most remarkable of the narrative scenes is the *Burial of Saints Cosmas and Damian*, where the grave is represented in perspective, like the open graves in the *Last Judgment*, but is integrated in an architectural scheme of great complexity, which anticipates that of Domenico Veneziano's *Miracle of St. Zenobius*. Along with the last scene, the *Dream of the Deacon Justinian*, it represents the summit of spatial sophistication achieved in Angelico's pre-Roman works.

Somewhat apart from the narrative panels stands that in the centre with the *Lamentation over the dead Christ*, which is conceived with an incomparable combination

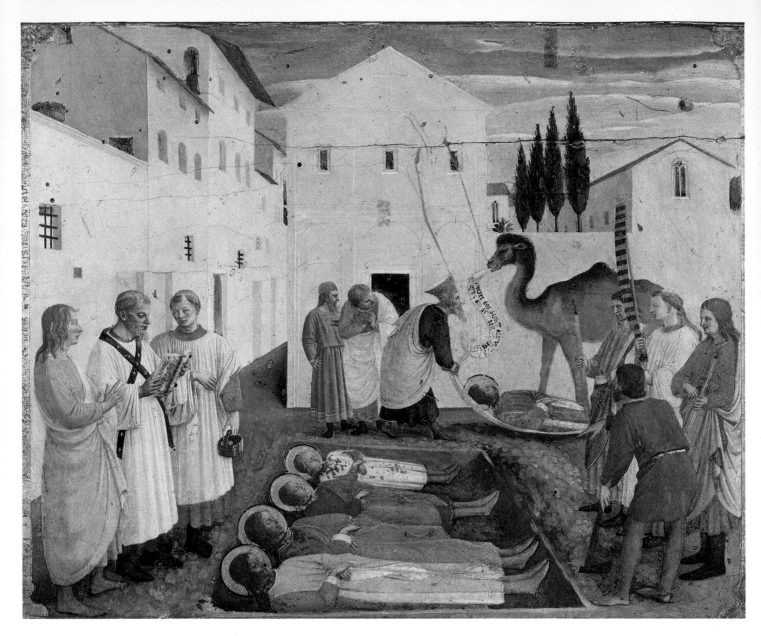

of logic and sentiment. The flat plane is here established by a rectangular void over the tomb, against which Christ's body supported by Nicodemus, is shown with arms raised horizontally by the adoring figures of the Virgin and St. John. Under it is the receding rectangle of the winding sheet, where the delicate naturalism of the folds and of the shadow cast by Christ's body surpasses that in any earlier work. Like the companion panels, the scene is illuminated from the right, but from a lower level, so that the beautifully rendered torso and the upper surfaces of the hands and forearms are strongly lit.

In the first half of the fourteen-forties the style of the San Marco predella was deployed on a larger scale in an altarpiece of the *Deposition*, now in the Museo di San Marco, executed for the Strozzi chapel in Santa Trinita. Painted on a single panel, the *Deposition* is surmounted by three finials by Lorenzo Monaco. In shape it recalls another altarpiece painted for Santa Trinita, the *Adoration of the Magi* of Gentile da Fabriano, and this, in conjunction with Lorenzo Monaco's close association with the church, suggests that it may originally have been commissioned from the older artist. Though the

Burial of Saints Cosmas and Damian
37 x 45 cm
Museo di San Marco, Florence.
From the predella of the San Marco Altarpiece.

(right)
Dream of the Deacon Justinian
37x45 cm
Museo di San Marco, Florence.
From the predella of the San Marco Altarpiece.

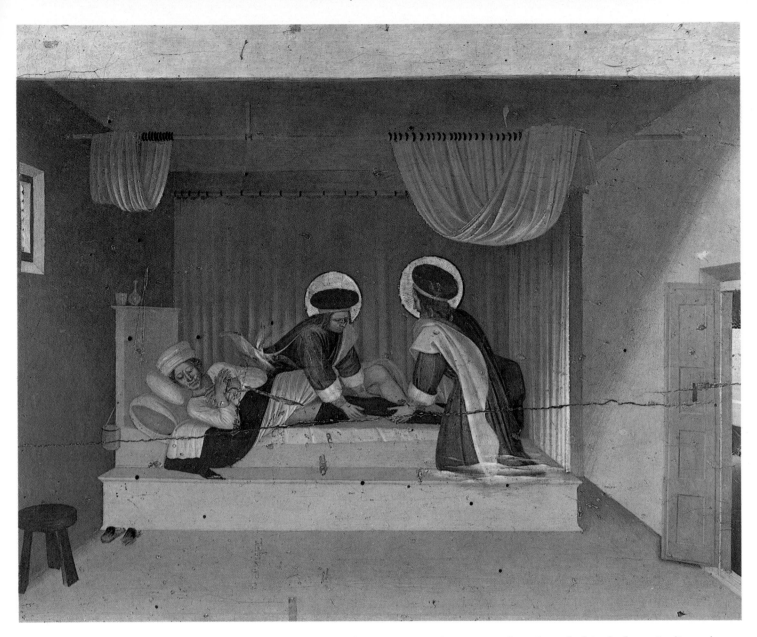

composition is deployed across the entire panel, the figures fall into three separate groups. In the centre the body of Christ is let down from the cross. As in the *Lamentation* panel from the San Marco altarpiece, the Christ is shown with arms outstretched, filling the whole of the centre of the scene. One of the two figures letting down the body, the Nicodemus, is said by Vasari to represent the architect Michelozzo. But if Michelozzo is portrayed, this is more probably in the head of a man wearing a black *cappuccio* below the Christ's right arm. Beneath, the body is received by an older male figure and by St. John. The group is completed by the Magdalen, kissing the feet of Christ, and by a kneeling Beato, perhaps the Beato Alessio degli Strozzi. Like the kneeling saints of the San Marco altarpiece, this figure, with eyes fixed on the central group and hand extended towards the onlooker, marks the transition from the real world of the spectator to the false world of the picture space. In the halo of Christ appears the words CORONA GLORIE, and below is a quotation from the eighty-seventh Psalm: ESTIMATVS SVM CVM DESCENDENTIBVS IN LACVM. To the left are the holy women, in their

centre the Virgin kneeling behind the winding sheet, and on the right is a group of male figures, one of whom exhibits the nails and crown of thorns. In the halo of the Virgin are the words: VIRGO MARIA N(ON) E(ST) T(IBI) SIMILIS, and beneath is the inscription: PLANGENT EVM QVASI VNIGENITVM QVIA INOCENS, while under the right side of the painting appears the verse: ECCE QVOMODO MORITVR IVSTVS ET NEMO PERCIPIT CORDE. The deliberate avoidance of the realistic detail proper to a normal narrative of the Deposition, the tender gestures with which the figures in the centre perform their ritual, and the restraint of the spectators, consumed by inner sorrow which finds expression in sympathetic lassitude rather than in rhetoric, are explained by the inscriptions, which lend the painting the character of a homily rather than of a narrative. The crown of glory won by the sacrifice of Christ, the sorrow of the Virgin with which no human sorrow can compare, the lament of the women for the innocent victim on the Cross as for their only sons, and the body of the Saviour, instinct with the promise of the Resurrection, — all these are phases in a meditation on the sufferings of Christ.

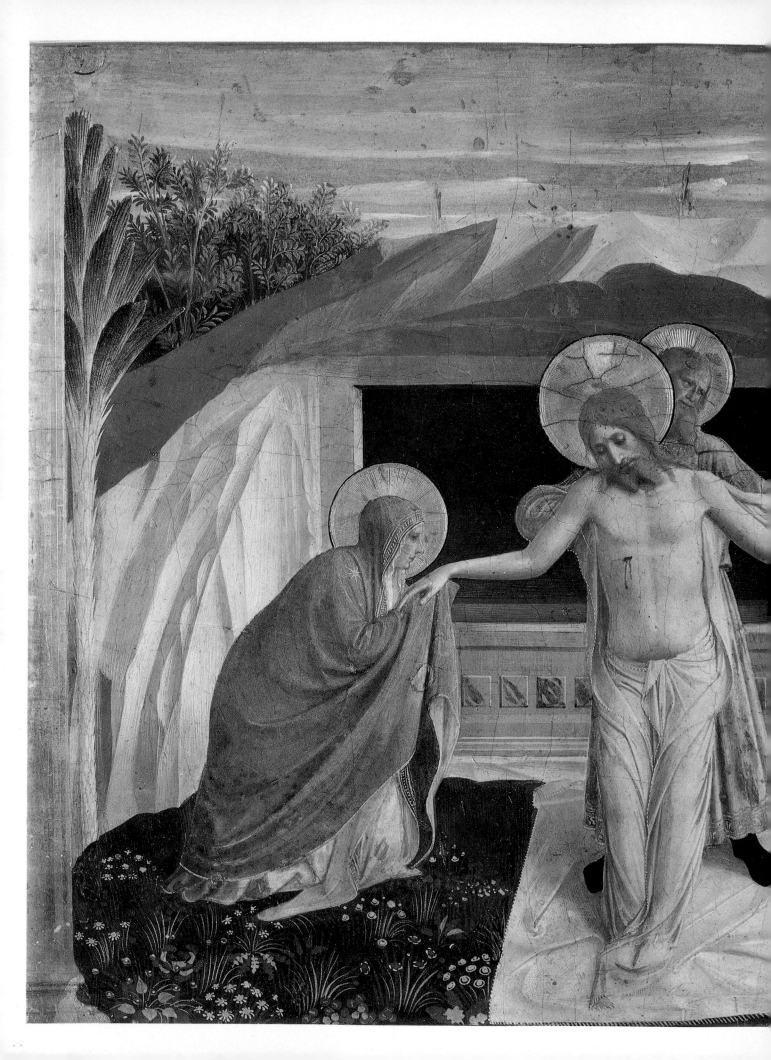

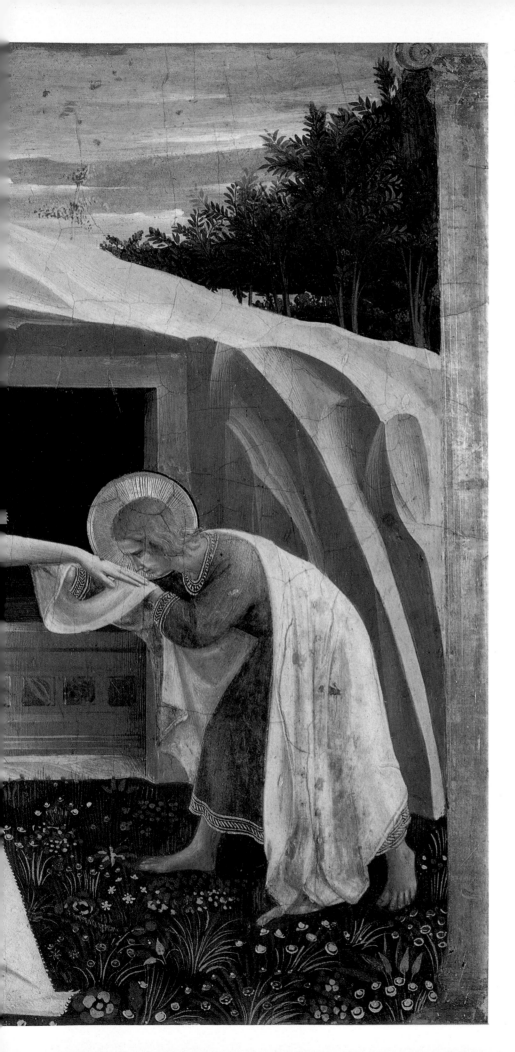

Lamentation over the dead Christ
38x46 cm
Alte Pinakothek, Munich.
The centre panel from the predella of
the San Marco Altarpiece.

The *Deposition* is at the same time a work of great intellectual inventiveness. Confronted by the Gothic panel prepared for Lorenzo Monaco, Angelico fills it with a composition which makes scarcely the least concession to its form. At the sides the scene is closed by standing figures whose verticality is accentuated on the left by the tower of a distant building and on the right by a tree. In the centre likewise the design is strongly vertical, and is established by the ladders standing against the Cross, by the right arm of Nicodemus lowering the body, and by the upright figure of Saint John. The body of Christ is set diagonally against the flat plane of the ladders, with the arms on an opposite diagonal and the head resting on the left shoulder, so that the long bridge of the nose is depicted horizontally, parallel to the steps of the ladders and the arms of the Cross.

An interesting feature of this painting are the intact pilasters, which are painted on the front and sides with

Deposition
176x185 cm
Museo di San Marco, Florence.
Painted for the Strozzi chapel in Santa Trinita around 1443, on a panel left unfinished by Lorenzo Monaco perhaps twenty-five years before.

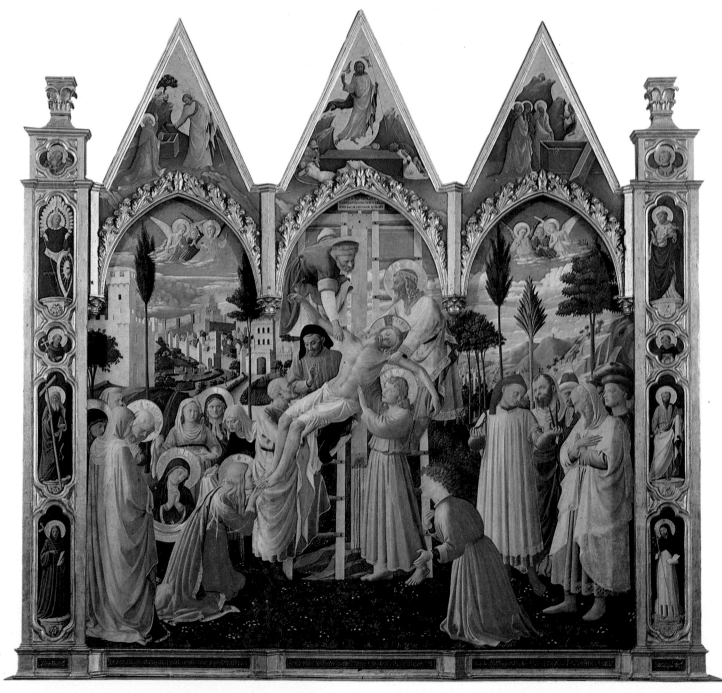

twelve full-length figures of saints and eight medallions. The saints stand on gilded plinths, which are adjusted to the place they were designed to occupy. Thus on the left pilaster at the front the plinth of St. Michael is depicted from beneath, with the upper surface hidden, and in that of St. Andrew, in the centre, part of the upper surface is shown, while the lowest, that of San Giovanni Gualberto, is represented from above.

Immediately before he left for Rome, Angelico seems to have undertaken a second Medicean altarpiece. Now in the Museo di San Marco it shows the Virgin and Child with Saints Peter Martyr, Francis, Lawrence, John the Evangelist and Cosmas and Damian, and is commonly known as the Annalena altarpiece. The Dominican convent of San Vincenzo d'Annalena was, however, founded only in 1450, was not rebuilt till 1453, and had no substantial oratory till after 1455, and we are bound therefore to suppose that the painting was commission-ed for some other purpose and was transferred to the convent in the fourteen-fifties after the painter's death. Support for this view is afforded by the fact that the altarpiece omits the Saints, Vincent Ferrer and Stephen, to whom the convent church was dedicated. It has repeatedly been claimed that the altarpiece was painted in the fourteen-thirties and precedes the high altar of San Marco. For a number of reasons this cannot be correct. First, the concentrated composition must follow, and not precede, that of the San Marco altarpiece. The system of projection used in it is essentially the same, and one device, the use of a curtain stretched across the back to isolate the figures, is common to both paintings, but in the Annalena altarpiece the front step of the throne is extended to a forward plane, and the six saints are grouped on two levels at the sides. Second, the architectural background, with its central tabernacle and arcaded wall unified by a common moulding at the top,

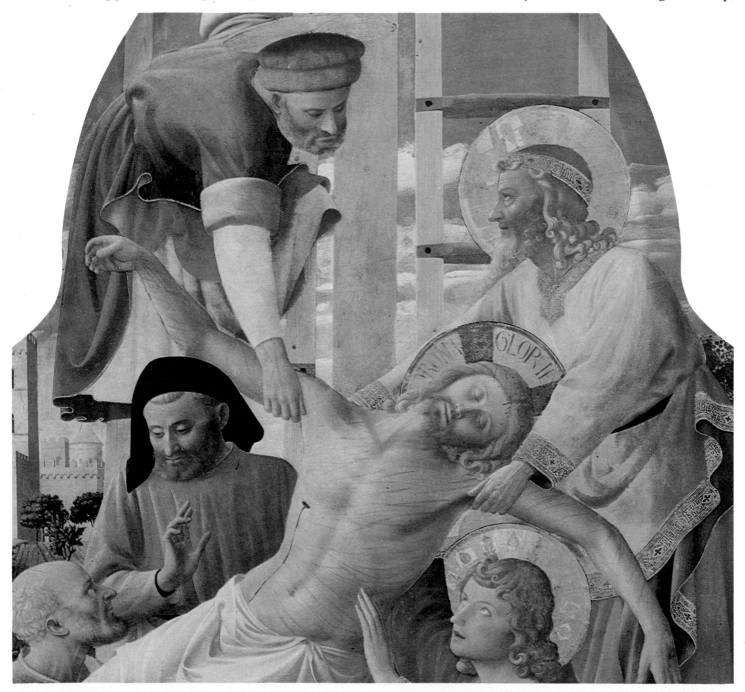

would be inexplicable in the context of the Cortona and Perugia polyptychs. Third, the predella, originally consisting of a central *Pietà* and of eight scenes from the legend of Saints Cosmas and Damian, of which seven survive, though not designed or executed by Angelico, makes use, in the figures on the left of the *Saints before Lycias*, in the onlookers at the back of the *Attempted Martyrdom by Fire*, and in the winding river of the *Decapitation* scene, of motifs which are manifestly drawn from the predella of the San Marco altarpiece. The fact that Angelico did not himself intervene in the predella, even to the extent of supplying the cartoons, suggests that at the time he moved to Rome only the main panel can have been complete.

Annalena Altarpiece
1443-5
180x202 cm
Museo di San Marco, Florence.

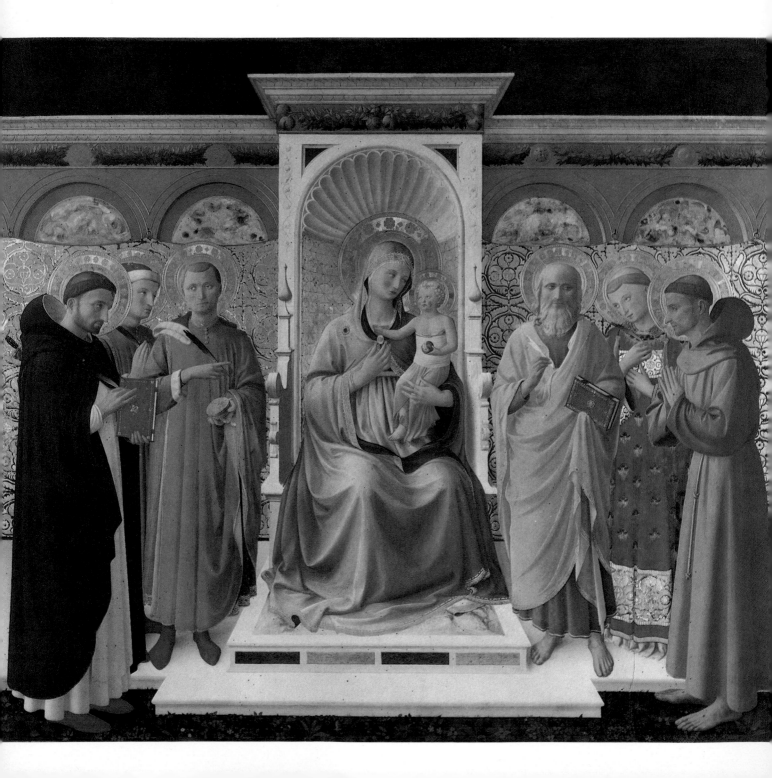

Rome
1445-9

In the second half of 1445 Angelico was summoned to Rome by Pope Eugenius IV to undertake frescoes in the Vatican. A sponsor of the Observant Movement, the Pope had lived for upwards of nine years in Florence, and in 1443 was himself present at the consecration of San Marco, when 'for the consolation of the friars in the convent he remained there the whole day, and spent the night in sleep in the first cell looking over the second cloister, which is now called the cell of Cosimo'. Whether or not the *Adoration of the Magi* in this cell was completed at the time of the Pope's visit, Eugenius must have been familiar with the painter and with his works in Florence.

The Rome of 1445 was no longer the desolate city to which Pope Martin V had returned a quarter of a century before. The pagan Pantheon had been restored, and a long line of artists from Central and North Italy — Masaccio and Masolino in San Clemente and Santa Maria Maggiore, Gentile da Fabriano and Pisanello in the Lateran basilica, Donatello and Filarete in St. Peter's — had left their mark upon its monuments. The Vatican, however, was not as yet the main focus of activity for artists in the papal city, and the work in the palace carried out by Fra Angelico forms the opening phase in a campaign of decoration and improvement that was to be pursued uninterruptedly until the Sack of Rome. At the Dominican convent of Santa Maria sopra Minerva, where he resided while in Rome, Angelico may have come in contact with the painter Jean Fouquet who was engaged at some uncertain date between the autumn of 1443 and the winter of 1446 in painting a portrait of Eugenius IV to commemorate the Pope's election at a conclave held in the convent in 1431.

Eugenius IV died on 23 February 1447, and his successor Nicholas V was elected Pope on 6 March. There is no direct evidence as to the task on which Angelico was engaged in 1445 and 1446, but the documents referring to Angelico's work in the Vatican under the new Pope are more explicit than some writers on the artist have supposed. Between 9 May and 1 June 1447 three documents refer to payments for the only surviving work painted by Angelico in Rome, the frescoed decoration of the Chapel of Nicholas V in the Vatican. On 11 May an arrangement was made, no doubt with the Pope's sanction, whereby Angelico spent the summer months at Orvieto, decorating the Cappella di San Brizio in the Cathedral. During June, July, August and the first half of September the master and his assistants were employed upon this work. The decoration of the Chapel was probably completed by the end of 1448, for by 1 January 1449 Angelico was engaged on another apartment in the Vatican, the 'studio di N.S.' or study of Nicholas V. This room, which had the double function of workroom and library, seems to have been adjacent to the chapel. Work in the study must have been less extensive than in the chapel, and it appears to have been well advanced by June 1449, when Gozzoli, Angelico's principal assistant, returned to Orvieto, and to have been completed by the end of the year or the first months of 1450 when Angelico returned to Florence.

Throughout his years in Rome Angelico must have been on terms of intimacy with the Pope in whose apartments he was employed. As Tommaso Parentucelli, Nicholas V had won fame as a scholar and bibliophile, and during his pontificate the papal court at Rome became a centre of humanistic studies. 'All the scholars of the world', writes Vespasiano da Bisticci, 'came to Rome in the time of Pope Nicholas, some of them on their own initiative, others at his invitation since he wished to see them at his court'. 'Under what pontiff', asks Birago in his *Strategicon adversus Turcos*, 'was this throne more splendid or magnificent?' The humanistic interests of Nicholas V found expression in his patronage of architecture and in his conservation of the monuments of Rome, and led to the commissioning of Piero della Francesca's lost frescoes in the Vatican. In addition to Angelico, two Umbrian painters, Bartolommeo di Tommaso da Foligno and Benedetto Bonfigli, were also employed at the papal court. For Angelico, trained in the sequestered precincts of San Domenico under the gaunt shadow of Dominici, the court of Nicholas V, with its wide intellectual horizons, represented a new world, the impact of which can be traced in the frescoes in the papal chapel.

They fill three sides of a small room, and consist of three lunettes, containing six scenes from the life of St. Stephen, and three rectangular frescoes beneath, containing five scenes from the life of St. Lawrence. Flanking the frescoes on the lateral walls are eight full-length figures of the Fathers of the Church, and on the roof are the four Evangelists. Beneath the frescoes are traces of a green textile design, which originally filled the lower part of the wall surfaces. The scheme was completed by an altarpiece of the *Deposition*, which was noted by Vasari but has since disappeared. The idiom of the frescoes in the Vatican is strikingly different from that of

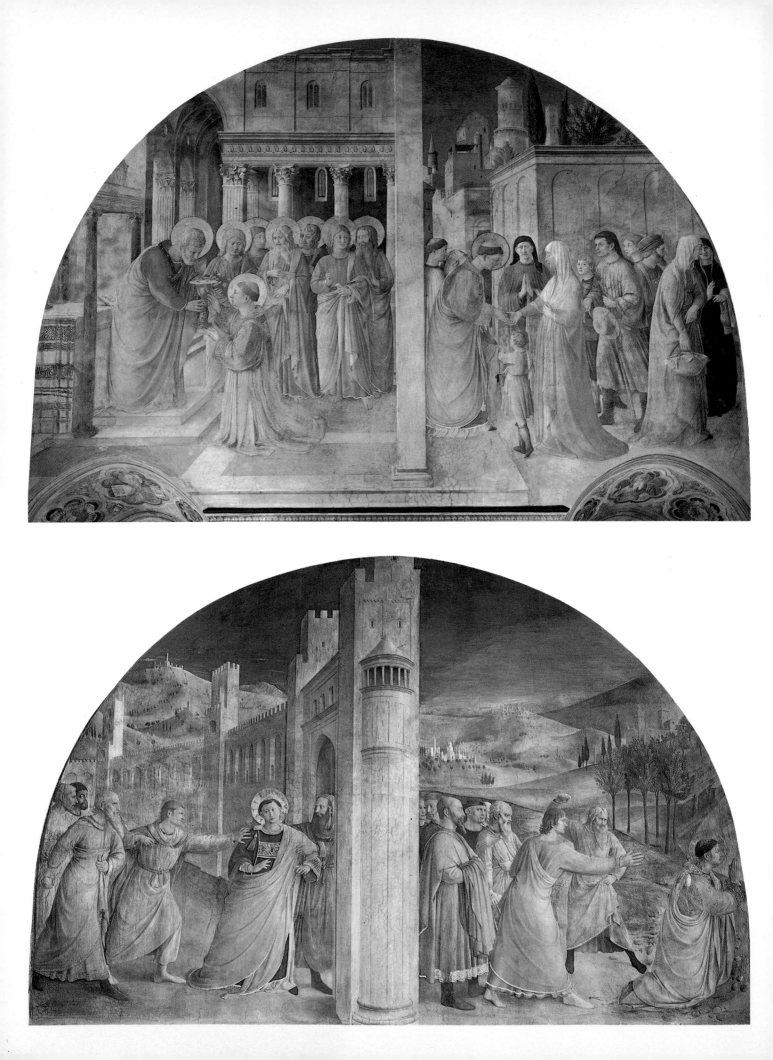

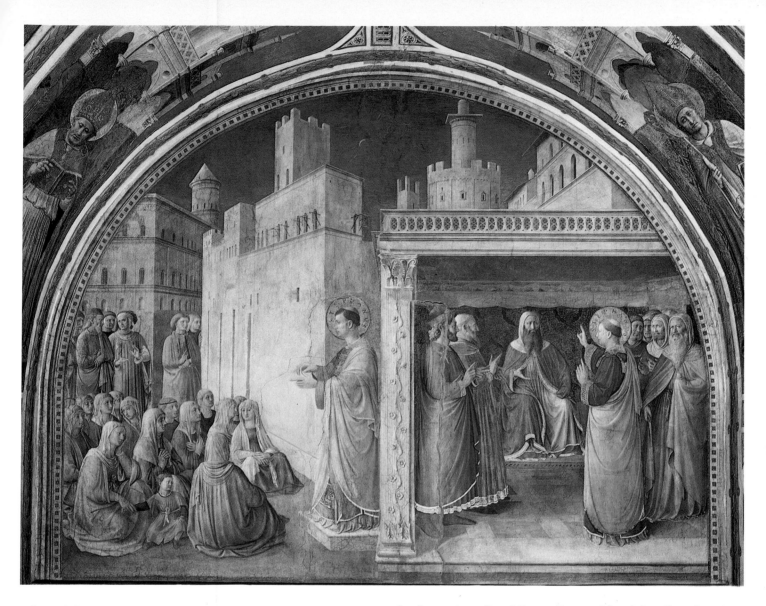

(above left)
Ordination of Saint Stephen and Saint Stephen distributing Alms

(above)
Saint Stephen preaching and Saint Stephen addressing the Council

(below left)
Expulsion and Stoning of Saint Stephen

The scenes from the lives of Saints Stephen and Lawrence in the Chapel of Nicholas V in the Vatican were painted by Angelico between 1447 and 1449. Among his assistants here and at Orvieto was Benozzo Gozzoli, some of whose work can be identified in these frescoes.

the frescoes at San Marco. In wealth of detail and variety of incident, in richness of texture and complexity of grouping, they violate the canons of the earlier scenes. But if we had to reconstruct the probable appearance of a fresco by the author of the San Marco predella, our mental image would resemble the frescoes in the Vatican more closely than those in the convent cells. Not only was the style of the San Marco frescoes governed by considerations which did not apply to the frescoes in the Vatican, but the narrative problem of the Vatican frescoes was, of its very nature, more intimately linked with Angelico's predella panels than with his frescoes. Hence it is wrong to regard the discrepancy between the fresco cycles as a measure of Angelico's development. In the normal course the lunettes above would have been painted before the scenes below. The upper frescoes are divided vertically in the centre by a wall serving a dual function in relation to the two parts of the scene. Thus the raised platform on which the *Ordination of Saint Stephen* takes place is continued in the contiguous scene of *Saint Stephen distributing Alms*; the background of towers and houses in the *Saint Stephen preaching* is common also to the *Saint Stephen addressing the Council*; and a single strip of landscape unifies the *Expulsion of*

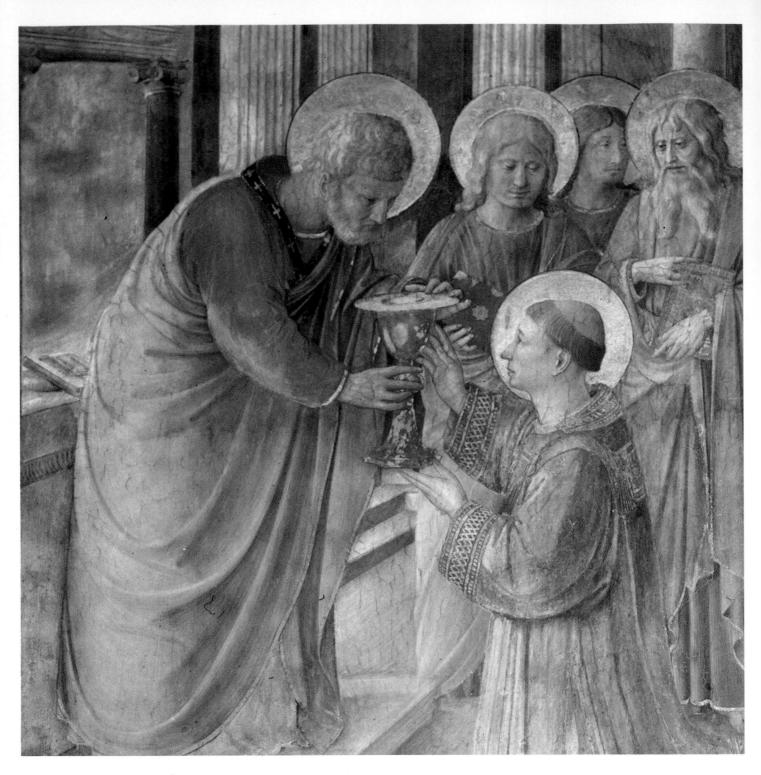

Saint Stephen and the *Stoning of Saint Stephen*. This consecutive narrative has no counterpart in the lower cycle, where each scene is independent of the next and three of the designs are centralised. Whereas the upper scenes have something of the character of enlarged predella panels, the scenes below establish a type of composition which remained constant in Florentine painting till the time of Ghirlandaio.

At the time the Saint Stephen frescoes were begun, Angelico had been in Rome for between twelve and eighteen months, and the change which this effected both in his style and in his architectural preconceptions is apparent in the first lunette, where the background of *Saint Stephen distributing Alms* is recognisably by the same artist as the *Burial of Saints Cosmas and Damian* in the predella of the San Marco altarpiece, while in the scene on the left, *The Ordination of Saint Stephen*, the setting takes on a strongly Roman character. Typically Roman are the ciborium over the altar before which Saint Stephen kneels and the columnar basilica depicted at the back. The stooping figure of Saint Peter and the Saint kneeling in profile are isolated in a forward plane, and behind, in the space between the altar steps and the columns of the nave, are six apostles, posed with the confidence and fluency of the saints in the Annalena altarpiece. Not the least unusual feature of this beautiful design is the use of the patterning of the floor to establish the axis of the scene.

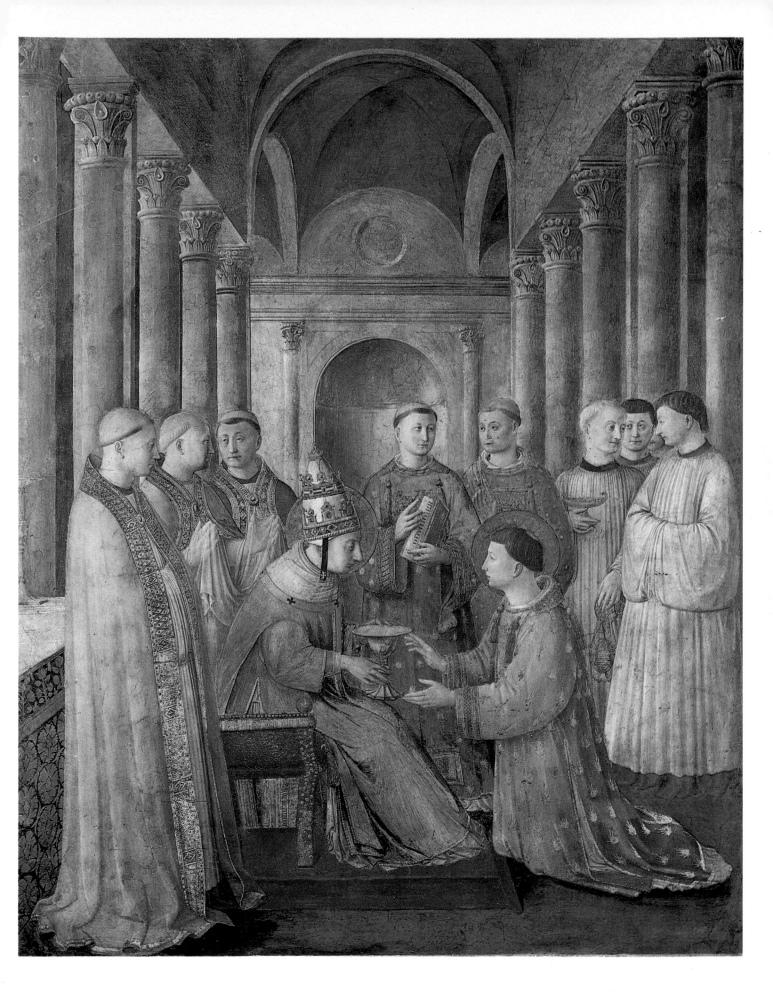

(left)
Detail from the Ordination of Saint Stephen.

Saint Lawrence distributing Alms
Chapel of Nicholas V, Vatican.

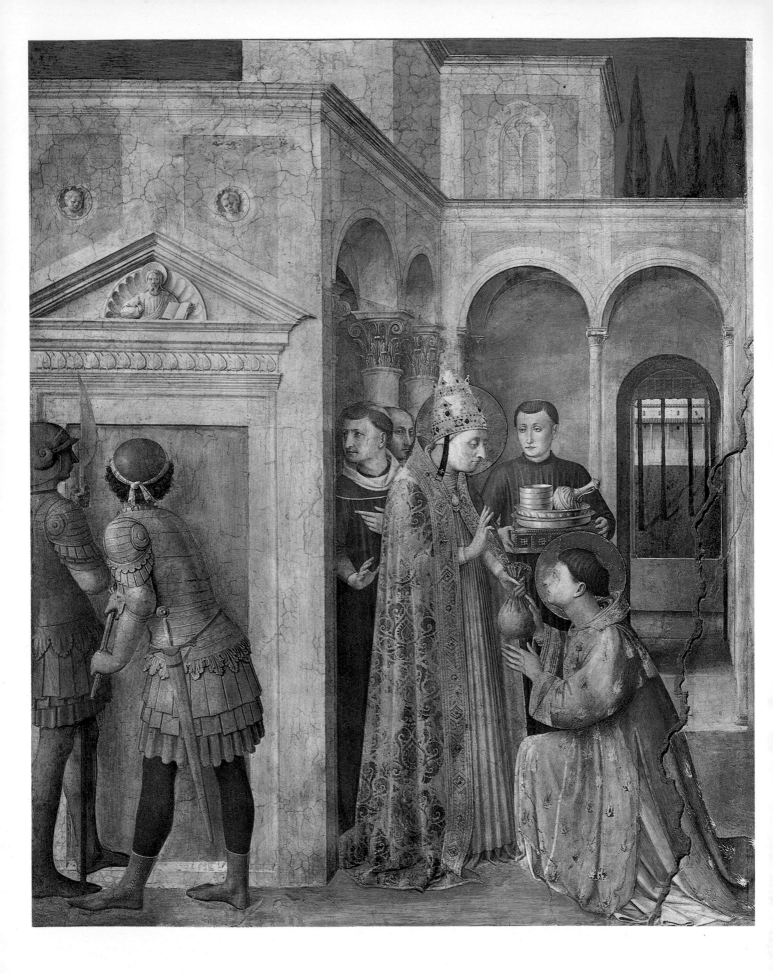

Saint Lawrence receiving the Treasures of the Church
Chapel of Nicholas V, Vatican.

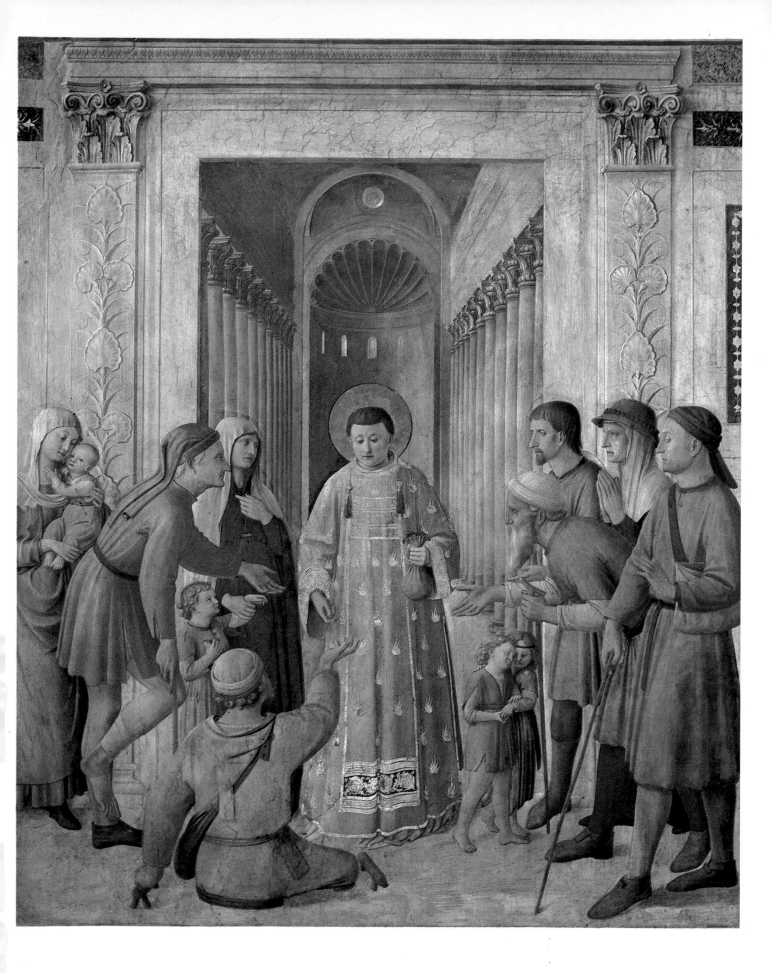

Ordination of Saint Lawrence
Chapel of Nicholas V, Vatican.

65

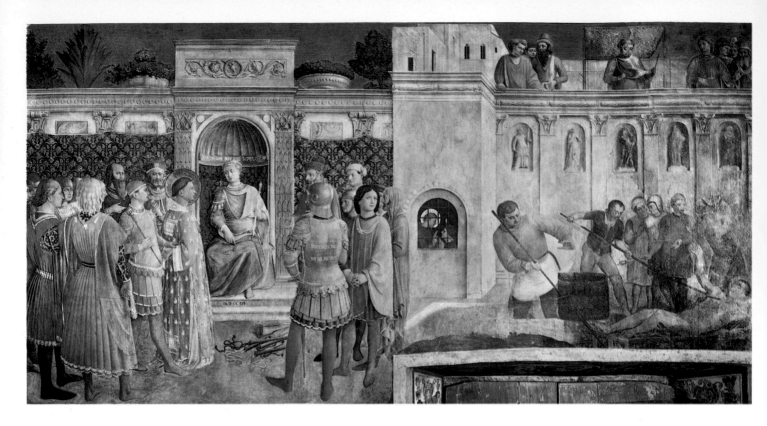

The scene of *Saint Stephen preaching* in the second lunette makes use of a rather different procedure, in which figures are deployed through the whole depth of the constructed space, and contrasts with the right half of the fresco, where the scene of *Saint Stephen addressing the Council* takes place in a low hall closed by a curtain on the wall behind. Here the figure of the Saint is turned inwards, and the orthogonals of the pavement lend force to the gesture of his raised right hand. The third lunette is divided by the city wall, which curves round at the back of the left scene, and like the figures and the distant landscape is illuminated from the right. The figures occupy the foreground of both scenes, and are dominated on the right by the kneeling figure of the Saint and on the left by the beautifully conceived figure of the Saint forcibly conducted through the gate. The landscape develops from the landscape of the *Deposition*, but is at once more panoramic and less intimate; in this it recalls the distant landscape of the predella panel of the *Visitation* at Cortona. In the use of trees on the right to establish the recession of the planes it owes something to the background of Masaccio's *Tribute Money*, and in the cosmic vision of the hill town on the left it recalls Masolino's *Crucifixion* fresco in San Clemente.

The scenes from the life of Saint Lawrence beneath mark the climax of Angelico's surviving work in Rome. Perhaps the most impressive of them is the first, which is set between the windows of the Chapel and can therefore be read as a self-consistent unit without reference to a companion scene. The act of ordination takes place in a columnar basilica of the type represented in the background of the *Ordination of Saint Stephen*, but here depicted from a cross section of the nave with five columns at each side receding to a central niche behind. The figures are not centralised, and the only feature in the foreground that is set decisively on a vertical through the vanishing point is the chalice extended by Pope Saint Sixtus II to the kneeling Saint. The Pope is represented with the features of Nicholas V and thus provides a precedent for the papal portraits incorporated in the Stanza della Segnatura and elsewhere in the Vatican. The second centralised fresco, *Saint Lawrence distributing Alms*, is treated rather differently. The nave, seen through the bold rectangle of the church entrance, is no more than a background, and the apse behind is used to lend emphasis to the figure of Saint Lawrence, who is shown forward of the façade in the centre of the scene. The figures in the *Ordination* scene and the figure of the Saint in the *Almsgiving* fresco are treated with new plastic emphasis.

(above)
Saint Lawrence before Valerianus and Martyrdom of Saint Lawrence
Chapel of Nicholas V, Vatican.

(right)
Detail from Saint Lawrence before Valerianus.

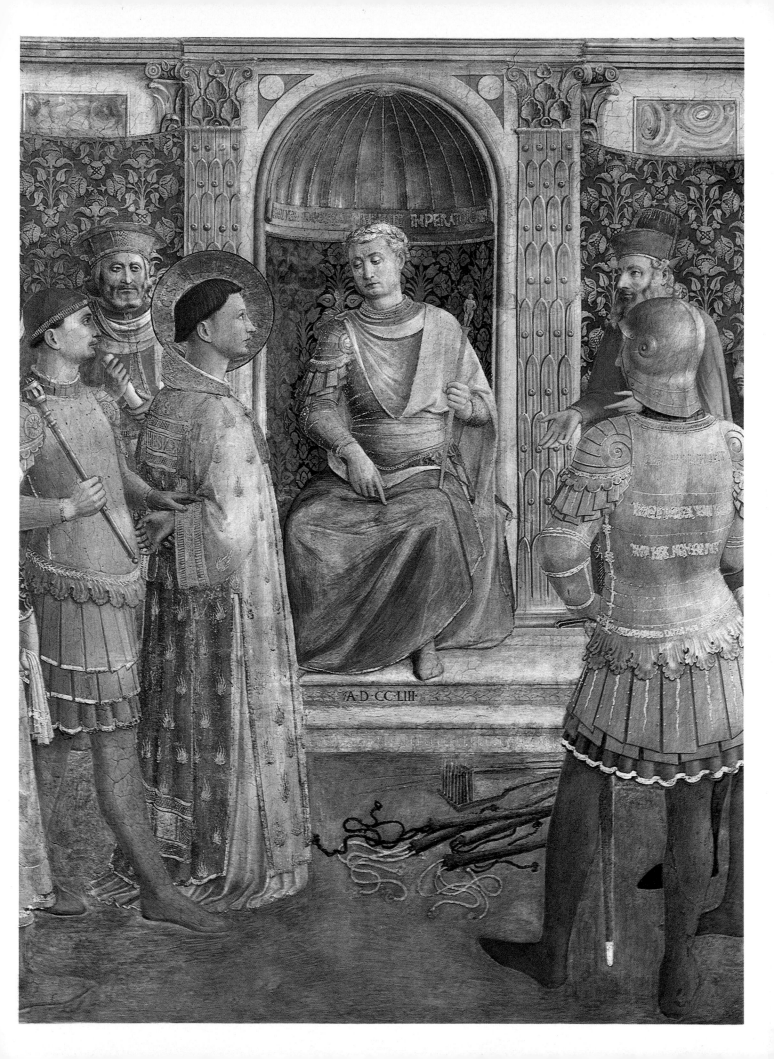

No attempt is made to link the *Saint Lawrence distributing Alms* to the scene of *Saint Lawrence receiving the Treasures of the Church* to its immediate left, though the main action in both scenes takes place in the same plane. The *Saint Lawrence before Valerianus* and the *Martyrdom of Saint Lawrence*, on the other hand, are connected by a cornice, which runs across the whole width of the two scenes. Visually this is not a wholly satisfactory device, the less that the two scenes are not artificially divided from each other, like the paired scenes which precede them, but are separated by the episode of the conversion of the jailer Hippolytus, seen through a window in the centre. The *Martyrdom* is the most seriously damaged of the frescoes. The field occupied by the fresco is considerably less high than that of the contiguous scene, and there must, from the outset, have been an awkward disparity of scale between them, but at least two of the executioners, and especially that on the left with green tights and a mustard-coloured shirt, are executed with great vigour and veracity.

Throughout these frescoes there was, to a greater extent than in any of Angelico's earlier commissions, a premium on enrichment. This is manifest in the architecture, which is less closely related to reality than that in the San Marco predella or in the earlier frescoes and reflects the influence of Alberti. A curious feature which recurs throughout the frescoes is the depiction of pilasters whose surfaces are covered with foliated ornament; these are related neither to classic pilasters nor to pilasters carved in the second quarter of the fifteenth century. The effect of the architecture is, moreover, weakened by colouristic emphasis. Whereas the buildings in the *Burial of Saints Cosmas and Damian* from the San Marco altarpiece are devoid of local colour, those in the Chapel of Nicholas V are diversified, like the architecture in Masolino's frescoes in San Clemente, with contrasting passages of pink. An extreme instance of this ambivalence is the fresco of *Saint Lawrence receiving the Treasures of the Church*, where the building on the left, largely by virtue of its colouring, makes an effect of artificiality, while on the right the distant vision of a cloister seen through an archway is portrayed with Angelico's customary veracity.

Beside the frescoes in the Vatican, the work completed by Angelico during his fourteen-week residence at Orvieto has attracted comparatively little interest. Engaged at the same salary as in the Vatican to paint for three months a year in the Cappella di San Brizio in the Cathedral, where the venerated corporal of the miracle of Bolsena was preserved, he filled two of the four triangular spaces on the ceiling of the chapel with a *Christ in Majesty with Angels* and *Sixteen Prophets*. Angelico's part in these frescoes was smaller than in the Vatican, and seems to have been limited to the much damaged figure of Christ and a group of angels on the left of the first fresco and to the heads of a number of the seated prophets in the second. A receipt of September 1447 shows that the assistants engaged upon this work were the same as those employed in Rome. The fact that two spaces so large could be painted in three and a half

months throws some light on the speed at which Angelico operated, and it is clear both in the Vatican and at Orvieto that the collaborative effort of his studio was the condition of his productivity. The contract for the frescoes must have been abrogated by 1449, when Gozzoli, who was working in Orvieto from July to December of this year, attempted to obtain the reversion of the commission. Forty years later Perugino was invited by the authorities of the Cathedral to complete the decoration of the chapel, and in 1499 this was at length entrusted to Signorelli. Criticism has tended to concentrate on the uneven handling of the ceiling frescoes of Angelico, and to underrate their spacious compositions and their noble forms.

(left)
The ceiling of the Cappella di San Brizio in the Cathedral at Orvieto.

Christ in Majesty
1447
Cappella di San Brizio, Cathedral, Orvieto.

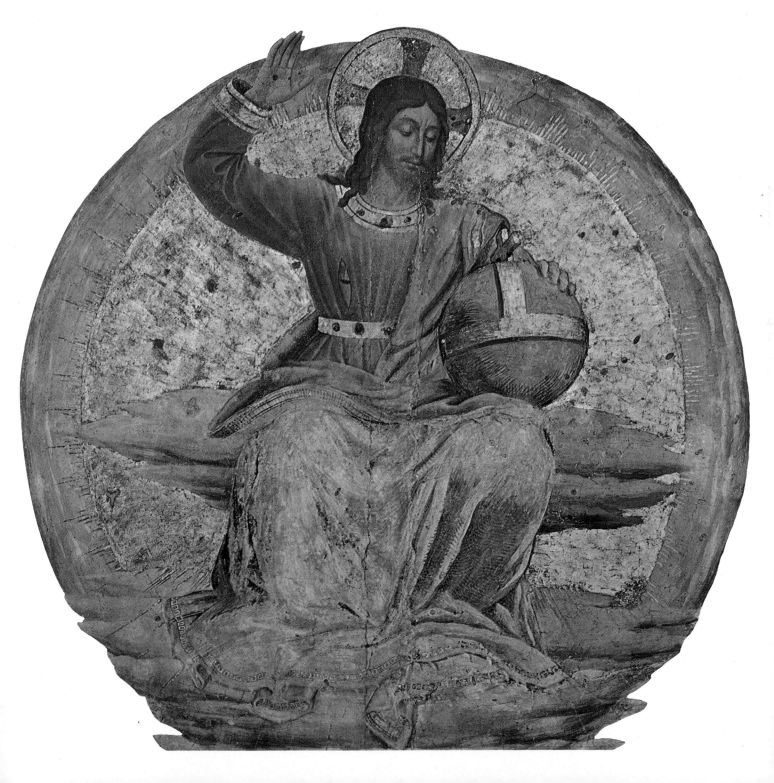

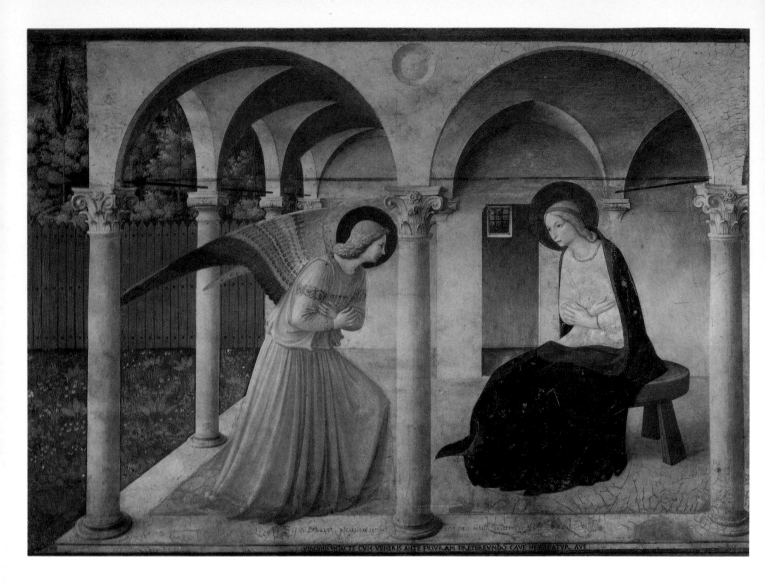

(above)
Annunciation
216x321 cm
Upper corridor, San Marco,
Florence.
Probably painted in 1450
upon Angelico's return from
Rome.

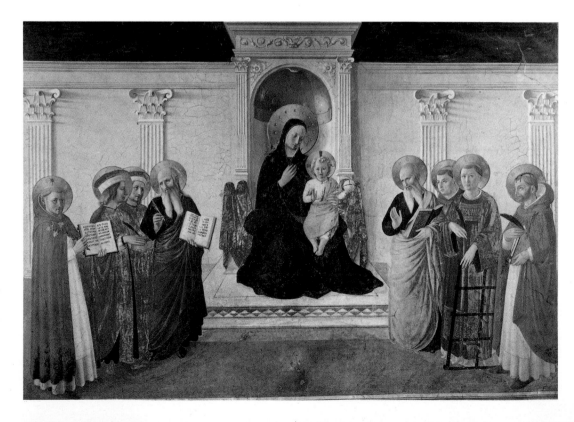

(right)
Virgin and Child Enthroned
with Saints Dominic, Cosmas,
Damian, Mark, John the
Evangelist, Thomas Aquinas,
Lawrence and Peter Martyr
c 1450
205x276 cm
Upper corridor, San Marco,
Florence.

Late Works
1450-5

In documentary terms little is known of Fra Angelico's activity between 1449 or 1450, when he returned to Fiesole as Prior, and 1455, when he died in Rome. Probably the first works he painted in Florence after his return were two frescoes in the upper corridor at San Marco, the *Annunciation* and the *Virgin Enthroned with eight Saints*. In the *Annunciation* the simple Michelozzan architecture of the *Annunciation* in Cell 3 is replaced by heavier columns with foliated capitals of a type which recur in the *Ordination of Saint Stephen* in the Vatican, and the figures are disposed on a diagonal, not as in the cell fresco and the altarpieces on a single plane. It has sometimes been suggested that this fresco is the work of an assistant, but the setting and the placing of the figures in it speak strongly against this view. In the second fresco the screen behind is articulated with pilasters which again recall the *Ordination of Saint Stephen*, and the Virgin's seat is placed well forward of the throne. The new spaciousness in the design and the new equilibrium between the figures and their background are found again in an altarpiece in the Museo di San Marco, which can be shown, on grounds of iconography, to have been executed after Angelico's return to Florence.

This was a commission from Cosimo de' Medici, and was designed for the high altar of the Franciscan church of San Buonaventura at Bosco ai Frati, not far from Cafaggiolo, which had been rebuilt by Michelozzo in the fourteen-thirties at Cosimo's charge. The date of the altarpiece is established by its predella, which contains a *Pietà* and six half-length figures of saints, among them San Bernardino, who was canonised only in 1450. The altarpiece must therefore have been painted after that year. It differs from the Annalena altarpiece in that the Virgin sits not on an architectural throne, but on a wide seat set on a middle plane. Behind her are two angels, whose types and dresses recall those of the angels in the Orvieto vault, and in the foreground are six saints, on the left Saints Anthony of Padua, Louis of Toulouse and Francis, and on the right Cosmas and Damian and Peter Martyr. The marble screen behind recalls the frescoes in the Vatican. In the centre is a niche of exceptional width, and at the sides are narrow arched recesses, where the relation of height to width is similar to that of the recesses in the wall behind the *Martyrdom of Saint Lawrence*. In the closely calculated composition Angelico transposes to panel painting the style he had evolved in Rome.

More problematical is the case of a second altarpiece, the *Coronation of the Virgin* in the Louvre, which seems to have been executed at this time. It was painted for San Domenico at Fiesole, and there has always been a consensus of opinion that it was produced either before 1430 or between 1430 and 1438. If that were correct, the adoption, for the pavement in the foreground, of a low viewing point would be the main fact to be explained, since this system of projection appears in Florence only in the fourteen-forties in Domenico Veneziano's St. Lucy altarpiece. The visual evidence suggests that the altarpiece must have been planned at a considerably later time. One of the features most often cited as proof of its early date is the Gothic tabernacle of the throne. The only true analogy for the tabernacle, however, occurs on the ceiling of the chapel in the Vatican, where the Fathers of the Church are depicted beneath canopies of the same kind. True, the canopy in the altarpiece is supported on spiral columns, not on flat pilasters, but the pilasters above the capitals (and a very odd architectural feature they are) are the same in both and so are the three front faces of the canopy. This dating is corroborated by the angels, who stand so stolidly beside the throne, their curls carefully crimped and their dresses starched in prim regular folds. They have little in common with the angels beside the throne in the San Marco altarpiece, but find an evident parallel in those in the frescoed vault of the Cappella di San Brizio at Orvieto.

A distinguished critic of Italian painting has described the *Coronation of the Virgin* as 'one of the few works in which Fra Angelico was thrown off his stride by strenuous efforts to keep up with the innovations around him'. The truth is rather that the artistic problem presented by the altarpiece was insoluble within the limits of the system of space projection Angelico employed. In the earlier *Coronation of the Virgin* from Santa Maria Nuova, the Saints at the sides sweep back in steady diminution till they reach the distant angels, and the figures of Christ and the Virgin, though smaller in size than the figures in the foreground, receive, by virtue of their isolation, appropriate emphasis. For Angelico about 1450 such a solution would have been unacceptable, and there was no alternative but to transfer the scene from notional space to real space like that of the San Marco altarpiece. If this were done, however, a steeply shelving foreground like that of the San Marco altarpiece would have been a liability since it would have given undue prominence to the foreground figures and insufficient prominence to the figures at the top. The solution Angelico adopted, therefore, was a compromise. The viewing point was lowered — Do-

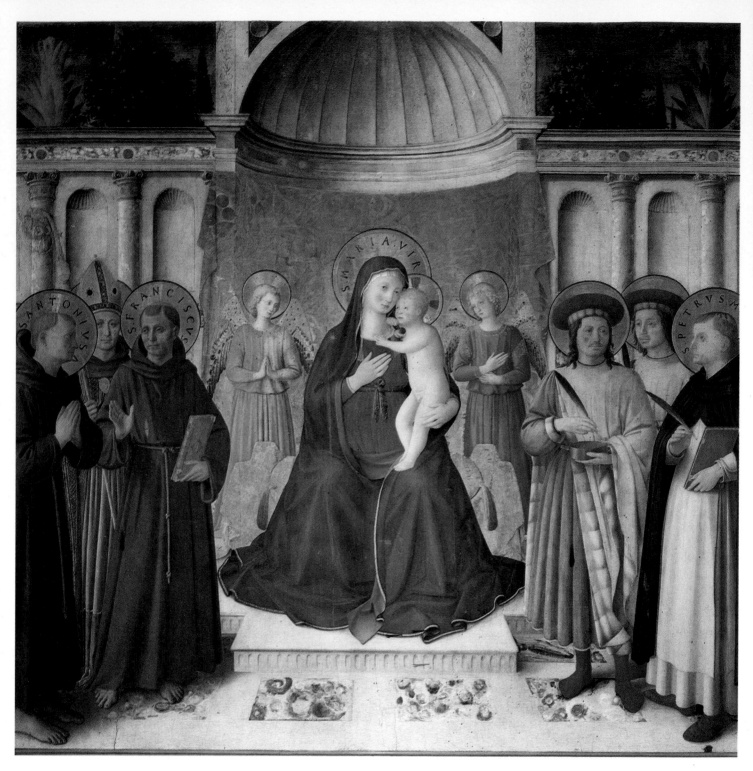

menico Veneziano's St. Lucy altarpiece was already in existence to prove how that could best be done — the foreground was projected on the new system, the canopy was portrayed from underneath, and the intervening area of the steps was filled in empirically. This is the only one of Angelico's large paintings in which the vanishing point and the narrative focus do not correspond, though the jar of ointment held out by St. Mary Magdalen, like the chalice in the *Ordination of Saint Lawrence* in the Vatican, falls on a central vertical.

The *Coronation of the Virgin* suffers from extensive studio intervention, especially on the righthand side. To take three examples only, the weakly drawn wheel held by St. Catherine, the tilted head of the female figure on the extreme right, and the blank-faced deacons above would be unthinkable in an autograph work. The parts painted by Angelico and especially the figures of Christ and the Virgin, are, however, of great distinction. Probably the altarpiece was still unfinished when Angelico died. Something of the kind is suggested by the predella, in which he had no share, and which seems actually to have been designed as well as executed by another artist.

The only fully authenticated late narrative panels by Angelico are a cycle of scenes from the life of Christ painted for the Annunziata, now in the Museo di San Marco. These panels are assumed, on the strength of a passage in the chronicle of Benedetto Dei, to have been commissioned by Piero de' Medici as the doors or shut-

(left)
Bosco ai Frati Altarpiece
c 1450-2
174x174 cm
Museo di San Marco, Florence.

Coronation of the Virgin
c 1450-3
213x211 cm
Louvre, Paris.

ter of the cupboard containing offerings in precious metal presented to the shrine of the Virgin Annunciate. The commission was bound up with a project for developing an oratory for Piero de' Medici's use between the chapel of the Virgin Annunciate and the convent library, and since the oratory was not roofed over till 1451 it is likely that the commission dates from this or the preceding year. The last payment relating to this phase in the production of the silver chest dates from 1453. Probably at this time what was envisaged were two doors opening outwards, but at a later stage, in 1461-3, the conception seems to have been revised, and the panels were incorporated in a single shutter hoisted by a pulley. In the form in which they are preserved,

they consist of thirty-five scenes, but they may originally have comprised an even larger number, since, with one exception the groups of panels read from left to right. The exception is the three scenes of the *Marriage Feast at Cana*, the *Baptism of Christ* and the *Transfiguration*, where the sequence runs from top to bottom; these are likely to be the concluding scenes from a block of nine which would have been devoted to the youth and early manhood of Christ.

The panels are mentioned after 1460 by Fra Domenico da Corella in the *Theotocon* as works of Fra Angelico, and on this account alone it is difficult to follow the many critics who deny his intervention in, or general responsibility for, these little scenes. All the

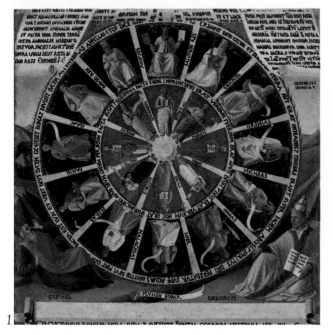

1

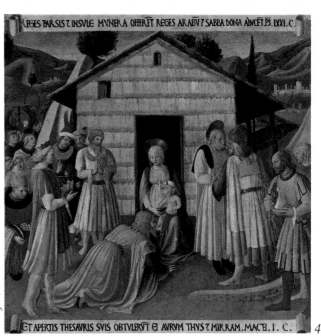

ECCE VIRGO CONCIPIET 7 PARIET FILIVM 7 VOCABIT NOMEN EIVS EMANVL. YSA. VI. C

ECCE CONCIPIES INVTERO 7 PARIES FILIVM 7 VOCABIS NOMEN EI IHESVM. LVCE. I. C.

2

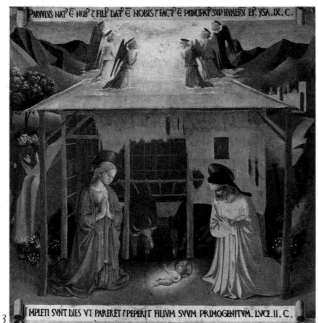

PARVVLVS NAT E NOB 7 FILI DAT E NOBIS 7 FACT E PRINCIPAP SVP HVMERV EI. YSA. IX. C.

IMPLETI SVNT DIES VT PARERET 7 PEPERIT FILIVM SVVM PRIMOGENITVM. LVCE. II. C.

3

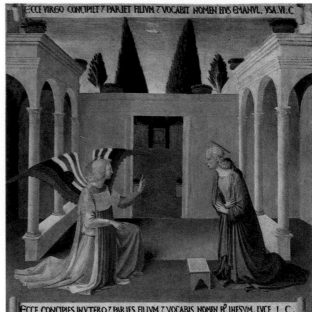

REGES TARSIS 7 INSVLE MVNERA OFFERET REGES ARABV 7 SABBA DONA ADDVCET. PS. LXXI. C

ET APERTIS THESAVRIS SVIS OBTVLERVT EI AVRVM THVS 7 MIRRAM. MACTEI. I. C.

4

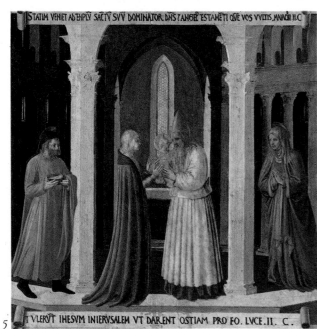

STATIM VENIET AD TEMPLV SACTV SVV DOMINATOR DNS 7 ANGEL TESTAMETI QVE VOS VVLTIS. MALACH II. C

TVLERVT IHESVM INIERVSALEM VT DARENT OSTIAM PRO EO. LVCE. II. C.

5

CIRCVCIDIMINI DOMINO VIRI IVDA 7 AVFERTE PPVTIA CORDIVM VESTRVM. IER. IIII. C.

POSTQVAB CONSVMATI SVNT DIES OCTO VT CIRCVCIDERET PVER VOCATV E NOM EI IHES. LVCE. II. C.

6

ELONGAVI FVGIENS 7 MANSI INSOLITVDINE . PS . XXXXXV . C

SVRGE ACCIPE PVERVM 7 MATREM . EP 7 FVGE INEGIPTVM . MACEI . II . C

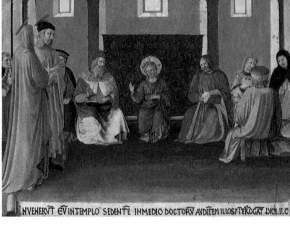

COFVSI SVT SAPIETES PTERRITI 7 CAPTI SVT . SAPIENTIA NVLLA EST . IN EIS . IERE . VIII . C

NVENERVT EV INTEMPLO SEDENTE INMEDIO DOCTORV AVDIEEM ILLOS 7 TEROGAT . LVCE . II . C

9

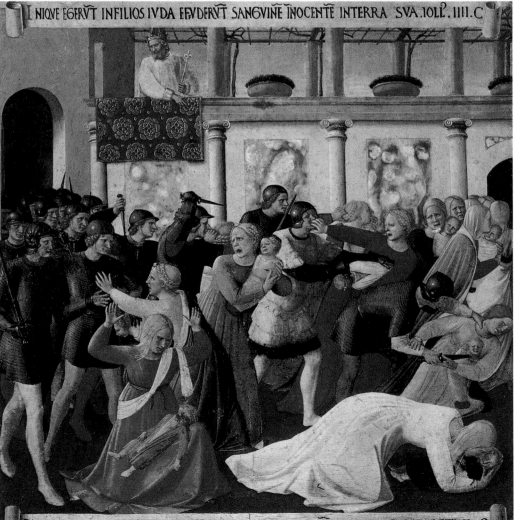

INIQVE EGERVT INFILIOS IVDA EFVDERVT SANGVINE INOCENTE INTERRA SVA . IOLP . IIII . C

RATVS ERODES OCCIDIT OMNES PVEROS QVI ERAT INBETHELEHEM . MACEI . II . C

The Annunziata Silver Chest
1451-3
each panel approx. 39x39 cm.
Museo di San Marco, Florence.
1. Vision of Ezekiel
2. Annunciation
3. Nativity
4. Adoration of the Magi
5. Presentation in the Temple
6. Circumcision
7. Flight into Egypt
8. Massacre of the Innocents
9. Christ teaching in the Temple 8

panels directly attributable to Angelico form part of the first block of nine paintings. The three succeeding scenes are by a younger artist, Baldovinetti, and the six missing scenes may have been by Baldovinetti too. The remaining twenty-three scenes are executed in the style of Angelico by another hand. Some of them incorporate motifs from the San Marco frescoes; this is the case with the *Mocking of Christ, Christ carrying the Cross* (where the Virgin corresponds with the related figure in the fresco of this scene), and the *Coronation of the Virgin* (where the central group is a variant of the fresco in Cell 9). Despite this, it is extremely difficult to regard these scenes as mere pastiches in the style of Fra Angelico, and a number of motifs — the continuous landscape behind the *Stripping of Christ* and the *Crucifixion*, the cloister in the scene of *Christ washing the feet of the Apostles*, the diagonal rhythm of the *Lamentation* — are so distinguished as to suggest that at the very least drawings for the whole cycle must have been made by the master. In January 1461 a payment was made to an otherwise unknown painter Pietro del Massaio for what is described as 'insegnare dipingere l'armario' (showing how the cupboard is to be painted). This might well refer to the execution in paint of antecedent cartoons. It has been noted correctly that the palette of the later scenes, and especially the extensive use of yellow in the *Betrayal*, differs from the practice of Angelico.

At the top and bottom of each panel are scrolls containing sentences respectively from the Old and the New Testament. Thus in the second scene Isaiah's prophecy of the Annunciation is balanced against the ECCE CONCIPIES IN VTERO ET PARIES FILIVM ET VOCABIS NOMEN EIVS IHESVM of St. Luke, and in the seventh a passage from the Psalms, ELONGAVI FVGIENS ET MANSI IN SOLITVDINE, is accompanied by the words put by St. Matthew into the mouth of the angel warning St. Joseph to flee. The programme must have been drawn up in its entirety before the panels were begun, and was thus planned by or in conjunction with Angelico. A key to the conception is to be found in the first and last panels, one executed under the master's supervision, the other by the artist who completed the chest. The first shows a landscape, in the lower corners of which are the seated figures of Ezekiel and Gregory the Great. Between them flows the River Chobar, beside which Ezekiel received his vision of God. In the upper left corner are passages from the fourth, fifth and sixteenth verses of the first chapter of Ezekiel, describing the appearance of four 'animalia' and a wheel within a wheel. In the opposite corner is the gloss of St. Gregory the Great upon this passage. The greater part of the panel is filled with two concentric circles, that in the centre containing eight standing figures of the Evangelists and writers of the canonical epistles, and that on the outside twelve figures of prophets. Round the perimeter of the smaller wheel run the opening words of the Gospel of St. John, and round the larger the account of the Creation. The last panel shows a flowery field. On the left stands a female

figure, the Church, holding a shield inscribed with the words LEX AMORIS. In the centre is a candlestick with seven branches, through which are threaded seven scrolls. On each scroll is the name of a sacrament accompanied to left and right by quotations from the Old and the New Testament. From the middle of the candlestick rises a pennant, surrounded by a twisted scroll, and to right and left, supported by twelve apostles and twelve prophets, are the articles of the Creed and the passages from the Old Testament with which they were habitually juxtaposed.

Though their handling and condition are unequal, the first nine scenes are distinguished by exquisitely lucid schemes, in which the essence of Angelico's late style is distilled. In the *Annunciation* the kneeling Virgin and the Angel are silhouetted against the central wall surface, the Angel pointing towards the Holy Ghost, which is represented naturalistically as a bird flying in the sky. The folds of their drapery are treated with great delicacy, and the haloes are shown in profile, not as in earlier paintings as flat circles on the picture plane. In the *Flight into Egypt*, where the haloes are fully visible, they are portrayed as metal discs which refract light and reflect the shadow of the head. A corollary of this is the exact rendering of the forms, witness the careful way in which the Virgin's forward leg beneath her robe has been defined. In the *Nativity* the stable is set in an alcove of landscape, and the play of perspective, in the handling of the horizontal struts and the forward-tilting manger, is more elaborate than in any earlier painting. In front it is divided by vertical supports into three equal parts, in one of which, behind St. Joseph, the straw comes down to shoulder height, while in the other, behind the Virgin, it is almost completely torn away. This three-fold division of the picture space is common also to the *Circumcision*, where the planes of the three end walls of the choir repeat the relationship of the three foreground figures, and to the *Presentation in the Temple*. The panel which reminds us most forcibly of the San Marco predella is the *Massacre of the Innocents*, where the wall at the back recalls that in *Saints Cosmas and Damian before Lycias*, but is enriched by a receding trellis. The spatial platform in the foreground is much deeper than before (in this it conforms to the structure of the frescoes in the corridor of San Marco), and the women filling it are treated realistically, with a repertory of posture that must, in its freedom and expressiveness, have appeared unsurpassed. There is, and this must be stressed very firmly, nothing archaic in these paintings. They prove that in the last years of his life Angelico was what he had been in youth and middle-age, a progressive, forward-looking artist.

The readiest explanation for the inconsistency of handling in the silver chest panels is that work on them was interrupted by some other commission; and since the break probably occurred in 1453 and Fra Angelico died in Rome in February 1455, it is a common

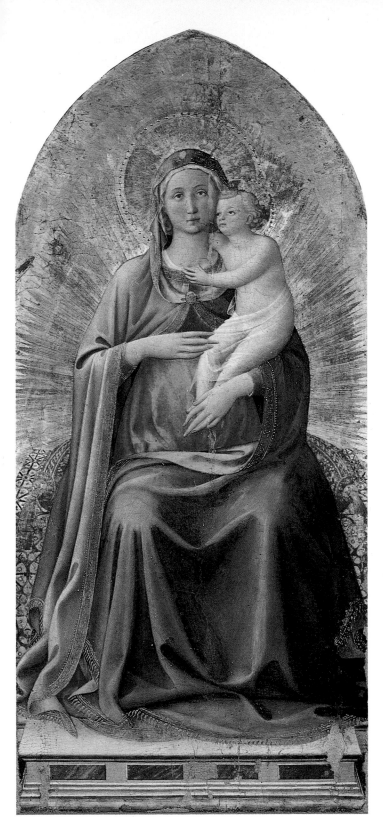

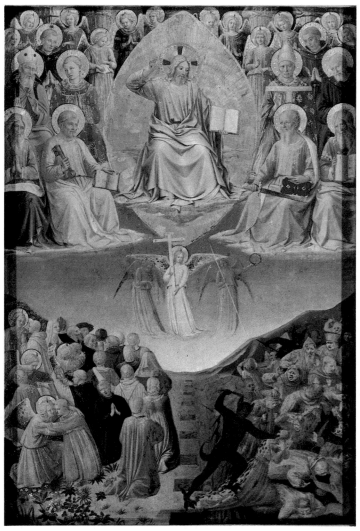

assumption that this was a commission from the Pope. Alternatively it has been suggested that the source of the commission may have been the church of Santa Maria sopra Minerva in Rome, for which, according to Vasari but no other source, Angelico painted the high altarpiece. There is no documentary proof of either supposition. We have, however, two small paintings by Angelico which may date from 1450-5, and a third more substantial picture on which work seems to have been started before his death. The first of the finished pictures is a panel in the Fogg Museum of *Christ on the Cross with*

the Virgin and Saint John adored by a Dominican Cardinal. This was originally the centre of a triptych, and the lower part of one of the two wings, with a cut-down figure of Saint Clement, survives. In type the Christ conforms, not to the fresco in the cloister of San Marco, but to the figure in the *Crucifixion* on the silver chest. The arms of the cross run the whole width of the panel, and above it burgeons a tree with at its tip a nesting pelican. The Virgin and Saint John, set slightly behind the cross, show the same tendency to elongation as the figures in the autograph *Presentation in the Temple* on

the silver chest, and the Cardinal, Juan de Torquemada, kneels in profile in the front. Both in its restrained intensity of feeling and in the severity of its design this is the most impressive of the artist's late paintings. The second work is a triptych with the *Ascension, Last Judgment and Pentecost* in the Palazzo Barberini. The central panel depends from the *Last Judgment* painted for Santa Maria degli Angeli, and among the blessed on the left two figures in the foreground are drawn with little variation from the earlier painting. In place, however, of the perspective view of the double line of open tombs, the foreground is divided by a single line of tombs running irregularly through the centre of the scene. The late date of the panel is asserted on the right by the figure of a woman chastised by a devil which is closely bound up with the women in the *Massacre of the Innocents* on the silver chest, and above in a still more decisive fashion by the Christ, which employs the same rhetorical pose as the *Christ in Glory* at Orvieto.

The more substantial picture is a famous tondo of the *Adoration of the Magi* in the National Gallery of Art in Washington. This is a bewildering work, not least because the bulk of the painting as we know it now was executed not by Angelico but by Fra Filippo Lippi. It was indeed consistently ascribed to Lippi until Berenson, in 1932, suggested that it was planned and partly painted by Angelico and an assistant about 1442 and was then completed by Lippi. This theory was later withdrawn, and the tondo was reascribed to Lippi. In both cases the analysis rested on the figurative content of the panel, not on its design. If, however, we look first at the ruined building on the left, whose structure is typical of Fra Filippo Lippi, and then at the walled city on the right, whose structure is typical of Fra Angelico, the dichotomy between the two appears so great that we are bound to postulate two separate designing minds. This deduction is confirmed by the irregular structure of the stable in the centre, which represents a point of compromise between two inconsistent schemes. That on the right is the more primitive, and we are bound therefore to suppose that work on the panel started in this area. This inference is warranted also by the fact that the figures on the left are in the main by Lippi, while the figures in the distance on the right are either by Angelico or by some member of his shop. The correct point of reference for them is not, however, the San Marco altarpiece or other paintings of the early fourteen-forties, but the panels of the silver chest, and this is corroborated by the only one of the main figures painted by Angelico, the seated Virgin in the centre, where the type and handling of the head are wholly different from those of Fra Filippo Lippi and the hair is braided like the hair of the silver chest *Maries at the Sepulchre*. It follows that the error in Berenson's analysis was not his explanation of the genesis of this great panel, but the date to which it was assigned. Though the panel as a work of art must in great part be credited to Lippi and its dominant style is undeniably Lippesque, it is not to be wondered at that in

Adoration of the Magi
(Cook Tondo)
c 1451-3
137.4 cm diametre
National Gallery of Art, Washington
(Kress Collection).
Completed after Angelico's death by Fra Filippo Lippi.

1492, thirty-seven years after Angelico's death, when it hung in a large room on the ground floor of the Medici Palace used by Lorenzo de' Medici, it was described as being 'di mano di fra Giovanni', that is by the hand of the legendary artist by whom it was begun.

When he died in 1455, Angelico was the most influential Florentine painter of his time, and the five hundred years that have elapsed since have produced no artist with so universal an appeal. The *Annunciation* at Cortona, the *Deposition* from Santa Trinita, the *Transfiguration* at San Marco form part of our common imaginative currency. They eschew the private idiom of other great religious artists, and reflect the serenity, the discipline, the anonymity of communal religious life. In

the case of Fra Angelico, more truly than in that of any other painter, the artist and the man are one. His paintings are informed with a tenderness, indeed affection, that gives tangible expression to the mystical virtue of charity, are undisturbed by profane interests and untinged by doubt. The language he employed resulted not from failure to keep abreast of the developments of his own day, but from intentions which differed fundamentally from those of other artists. For all the translucent surface of his paintings, for all his pleasure in the natural world, there lay concealed within him a Puritan faithful to his own intransigent ideal of reformed religious art.

In the empathy of his approach to religious iconography (it is as though in every painting the artist himself were present as an unseen participant), in the compassion which bulks so large throughout his work, in the sense of divine immanence in nature (which proceeds directly from Dominican Observant doctrine), in the benign light of faith that gives his paintings their warmth and their consistency, in the undeviating single-mindedness with which he followed his allotted path, Fra Angelico is unlike any other artist. No painter's works have been so widely reproduced, and though from the standpoint of good taste we may deplore the copies of them that surround us on all sides, they still perform the function they were originally designed for, and testify to the continuing value of his apostolate.

Selected Bibliography

U. Baldini, *L'opera completa dell'Angelico*, Milan 1970
B. Berenson, *The Florentine Painters of the Renaissance*, New York 1909
B. Berenson, *Italian Pictures of the Renaissance: Florentine School*,
 London 1963
L. Douglas, *Fra Angelico*, London 1900
M.L. Gengaro, *Il Beato Angelico a San Marco*, Bergamo 1944
A. Jahn-Rusconi, *Il Museo di San Marco a Firenze*, Milan 1950
Mostra delle opere del Beato Angelico (catalogue), Florence 1955
P. Muratoff, *Frate Angelico*, Italian ed. Rome 1930
S. Orlandi, *Beato Angelico*, Florence 1964
R. Papini, *Fra Giovanni Angelico*, Bologna 1925
M. Salmi, *Il Beato Angelico*, 1958
F. Schottmüller, *Fra Angelico: des Meisters Gemälde*, Stuttgart 1924
M. Wingenroth, *Angelico da Fiesole*, Leipzig 1905
A. Wurm, *Meister- und Schularbeit in Fra Angelicos Werk*, Strassburg 1907